Gainsborough as Printmaker

Gainsborough as Printmaker

John Hayes

Published for
The Paul Mellon Centre for Studies in British Art (London) Ltd
by Yale University Press, New Haven and London 1972

Library of Congress catalog card number: 79-179475
International standard book number: 0-300-01561-5

Designed by Graham Johnson/Lund Humphries
and printed in England by Lund Humphries.

Distributed in Canada by McGill-Queen's University Press, Montreal;
in Latin America by Kaiman & Polon, Inc., New York City.

For
my friends and colleagues
in Print Rooms
throughout the world

Contents

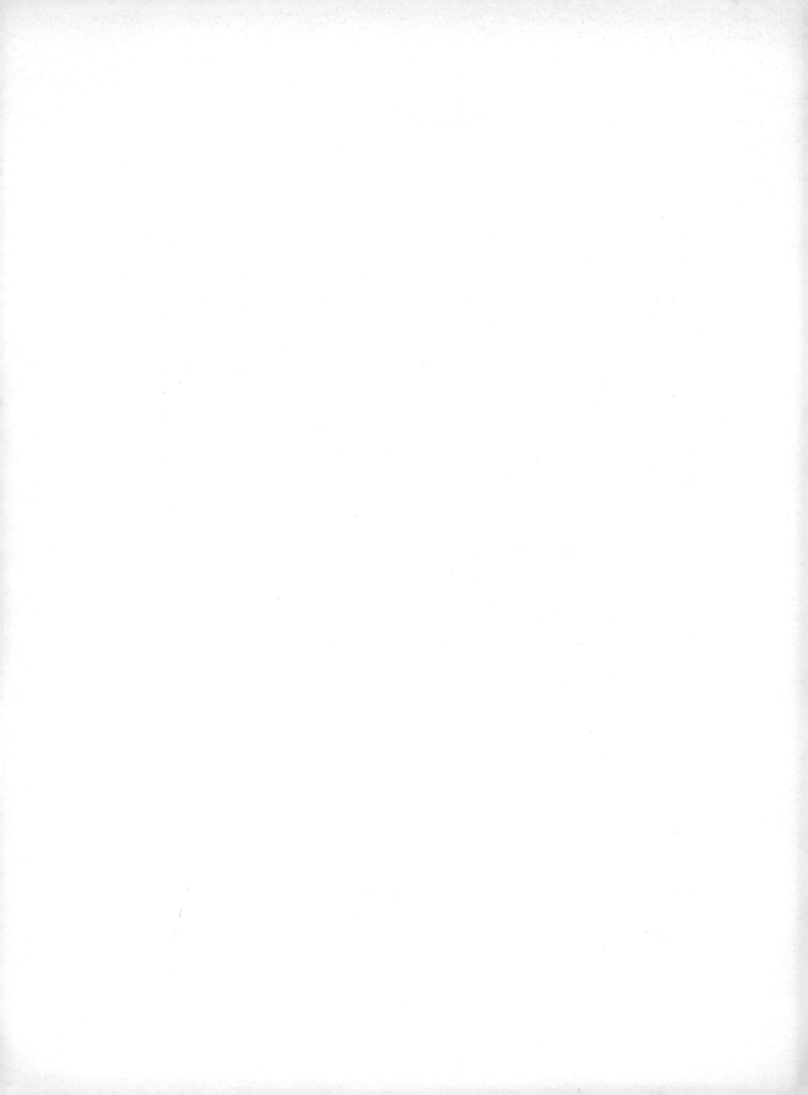

Preface

It is a singular fact that the first art historian to pay any attention to Gainsborough's prints was a German, Max Friedländer, whose short but perceptive article on the subject appeared in *Kunst und Künstler*, again paradoxically, during the course of the first world war. They were discussed by Hind in the broader context of mid and late eighteenth-century English printmaking in 1921; and Mary Woodall appended a brief note and list to her pioneer study of Gainsborough's landscape drawings published in 1939. Certainly they have now become far better known, and more highly regarded, than when Friedländer sought in vain for information from the English art trade just before 1914, but a complete catalogue raisonné has never been attempted; nor have more than half the prints – and few of the early states – been as much as illustrated. Gainsborough was by no means a prolific printmaker, but his work was of immense originality, power and distinction none the less, and he played an important part in the development and enrichment of the processes of aquatint and soft-ground etching. It is hoped that the following pages will enable students to arrive at a clearer understanding of his achievement in this field and therefore of his art as a whole.

For help of various kinds in the preparation of this volume I am indebted to: Norman Baker; Dr K. G. Boon and Dr Liericke Frericks of the Rijksmuseum; Martin Butlin and Leslie Parris of the Tate Gallery; Miss Beverly Carter and Miss Nancy Wasell of the Paul Mellon Collection; Rollo Charles and Peter Hughes of the National Museum of Wales; Messrs Craddock and Barnard; Arthur Driver, Miss Catherina Mayer and Stephen Somerville of Colnaghi's; Paul Drury of Goldsmiths' College, who initiated me into the technique of soft-ground etching; Ian Fleming-Williams; Edward A. Foster of the Minneapolis Institute of Arts; Hugh J. Gourley of the Providence Museum of Art; Professor Lawrence Gowing; Paul Hulton, Andrew Wilton and Eric Harding of the British Museum Print Room; Hyatt Mayor, formerly Curator of Prints at the Metropolitan Museum; Miss Ruth S. Magurn of the Fogg Art Museum; P. N. McQueen of Thomas Ross & Son; Christopher Mendez; Nicholas Plumley; Dr Heinrich Schwartz of the Davison Art

Center in Middletown; Dudley Snelgrove; John Sunderland of the Witt Library; Dr Frauke Steenbock, Director of the Berlin Museumsbibliothek; Philip Troutman of the Courtauld Institute Galleries; Robert R. Wark of the Henry E. Huntington Art Gallery; Mrs Juliet Wilson; Dr Matthias Winner and Dr Alexander Dückers (who has been especially forbearing with my detailed enquiries) of the Berlin Kupferstichkabinett, and Dr Hans Möhle, formerly of the same institution; Professor Andrew McLaren Young of Glasgow University; and Carl Zigrosser, who first encouraged me to produce this book. I am also grateful, as always, to the staffs of the numerous print rooms who have given me such excellent facilities for study, in particular my colleagues in the British Museum.

I owe a particular debt of gratitude to Luke Herrmann, who subjected the text to a careful scrutiny and suggested a number of important changes in arrangement. The text has also been read by Robert Wark, whose pertinent suggestions for improvement I have been happy to adopt, and by Leslie Parris, who corrected me on several points of detail. For help on matters of technique, an especially vexatious problem in the case of an artist as experimental as Gainsborough, I am greatly indebted to Lawrence Josset. The index was planned with her customary imagination and common sense by Miss Joan Pollard.

The extracts from *The Farington Diary* are published by gracious permission of Her Majesty The Queen, and the letter from Margaret Gainsborough by permission of the Ipswich Museums Committee. My sincerest thanks are due also to all those owners who have kindly allowed me to reproduce paintings, drawings or prints in their possession.

J.H.
December, 1970

List of Illustrations

NOTE All illustrations are of works by Gainsborough unless otherwise stated. Sizes are given in inches, with millimetres in brackets. Height precedes width. Where plate sizes differ from composition sizes, the latter only are given.

10. Three cows on a hillside (No.3). Aquatint with drypoint. 5×8 (127×203). Early 1770's. *British Museum (1872–6–8–283)*.

11. *Benjamin Green (c.1736–1800)*. Head of an old man. Soft-ground etching after Bossi. 5½×4⅜ (140×111). Published 25 December 1771. *British Museum (1861–10–12–2393)*.

12. Detail from Pl.46.

13. Detail from Pl.47.

14. Detail from Pl.48.

15. Wooded landscape with herdsman driving cattle over a bridge, rustic lovers and ruined castle (No.11). Second state. Soft-ground etching. 11 ¹³⁄₁₆ × 15½ (300×394). 1779–80. *Henry E. Huntington Library and Art Gallery*.

16. Detail from Pl.58.

17. Detail from Pl.59.

18. Detail from Pl.54.

19. Detail from Pl.87.

20. Detail from Pl.90.

21. Detail from Pl.86.

22. *John Robert Cozens (1752–97)*. The Oak. Soft-ground etching. 9 ⁷⁄₁₆ × 12 ¹¹⁄₁₆ (240×322). From his series of *Trees*, published 1789. *British Museum (1893–1–24–3)*.

23. *John Sell Cotman (1782–1842)*. Mountainous river landscape with cows and bridge. Soft-ground etching. 5×6 ¹⁵⁄₁₆ (127×176). Artist's proof for his *Liber Studiorum*, published 1838. *British Museum (1859–5–28–168)*.

24. *Thomas Rowlandson (1756 or 1757–1827)*. Mountain landscape with herdsman driving cows past a cottage. Soft-ground etching with aquatint after Gainsborough. 10¼×14¼ (260×362). Contained in Rowlandson's *Imitations of Modern Drawings*, c.1788. *British Museum (52–7–5–231)*.

25. *Thomas Rowlandson (1756 or 1757–1827)*. Wooded landscape with figures bundling faggots, cows and sheep. Soft-ground etching and aquatint after a drawing by Gainsborough then in the collection of C. F. Abel. 10 ³⁄₁₆ × 12 ¹¹⁄₁₆ (259×322). Published by J. Thane, 21 May 1789. *British Museum (1878–7–13–2234)*.

26. Wooded landscape with church, cow and figure (No.1). First state. Etching. 3 ¹⁵⁄₁₆ × 6⅛ (100×156) 1753–4. *University of Glasgow*.

27. Wooded landscape with church, cow and figure (No.1). Second state. Etching. 3 ¹⁵⁄₁₆ × 6⅛ (100×156). 1753–4. *University of Glasgow*.

28. Wooded landscape with church, cow and figure (No.1). Third state. Etching. 3 $\frac{15}{16}$ × 6$\frac{1}{8}$ (100 × 156). 1753–4. *University of Glasgow.*

29. Wooded landscape with figure crossing a bridge, cows and church. Canvas. 25 × 30 (635 × 762). About 1752–4. *Bowes Museum, Barnard Castle.*

30. Wooded landscape with church, cow and figure (No.1). Etching. Published by Joshua Kirby in his *Dr. Brook Taylor's Method of Perspective Made Easy*, 1754. 3 $\frac{15}{16}$ × 6$\frac{1}{8}$ (100 × 156). *British Museum (1878–12–14–158).*

31. Wooded landscape with herdsman and cow. Pencil. 11 × 15$\frac{1}{8}$ (279 × 383). About 1758–9. *Sir John and Lady Witt, London.*

32. *Joseph Mallord William Turner (1775–1851).* Wooded landscape with church, cow and figure (after Gainsborough). Grey wash. 6$\frac{1}{8}$ × 8 $\frac{1}{16}$ (155 × 205). About 1790–1. *Princeton Art Museum (57–1).*

33. Gipsies under a tree. Canvas (unfinished). 19 × 24 (483 × 610). Early 1750's. *Tate Gallery, London (5845).*

34. Wooded landscape with gipsies round a camp fire (No.2). First state. Engraving. 18 $\frac{9}{16}$ × 16$\frac{1}{2}$ (471 × 419). 1759. *British Museum (1877–6–9–1774).*

35. Wooded landscape with gipsies round a camp fire (No.2). Second state. Engraving. 18$\frac{1}{2}$ × 16$\frac{1}{2}$ (470 × 419). 1759. *National Museum of Wales, Cardiff.*

36. Wooded landscape with gipsies round a camp fire (No.2). Engraving. 18$\frac{5}{8}$ × 16$\frac{9}{16}$ (473 × 421). As published by J. Boydell, 1764. *British Museum (1866–11–14–310).*

37. Three cows on a hillside (No.3). Aquatint with drypoint. 5 × 8 (127 × 203). Early 1770's. *British Museum (1872–6–8–283).*

38. Three cows on a hillside. Watercolour, varnished. 7 $\frac{5}{16}$ × 9$\frac{1}{4}$ (186 × 235). Early 1770's. *British Museum (G.g.3–390).*

39. Hilly wooded landscape with herdsman and cattle. Pencil and watercolour on brown toned paper, varnished. 7 $\frac{11}{16}$ × 9 $\frac{11}{16}$ (195 × 246). Later 1760's. *Mrs J. Peyton-Jones, London.*

40. *Thomas Rowlandson (1756 or 1757–1827).* Three cows on a hillside. Soft-ground etching with aquatint after Gainsborough. 6$\frac{1}{8}$ × 8 $\frac{5}{16}$ (156 × 211). Contained in Rowlandson's *Imitations of Modern Drawings, c.*1788. *British Museum (M40–15).*

41. Wooded landscape with figures, boat and cows beside a pool (No.4). Soft-ground etching with aquatint. 9$\frac{3}{4}$ × 12$\frac{5}{8}$ (248 × 321). Mid to later 1770's. *Ehemals Staatliche Museen, Berlin–Dahlem (185–1913).*

42. Wooded landscape with gypsy encampment. Black chalk and stump and white chalk on blue paper. 10$\frac{1}{2}$ × 12$\frac{7}{8}$ (267 × 327). Later 1770's. *From the collection of Mr and Mrs Paul Mellon, Oak Spring, Virginia (67/12/5/5).*

43. Wooded landscape with figures and cattle at a pool. Black chalk and stump on brown paper, heightened with white. $9\frac{5}{16} \times 12\frac{1}{8}$ (237×308). Later 1770's. *John Tillotson, London.*

44. Wooded landscape with cows beside a pool, figures and cottage (No.5). Soft-ground etching with aquatint. $10 \times 12\frac{3}{4}$ (254×324). Mid to later 1770's. As published by J. & J. Boydell, 1 August 1797. *Metropolitan Museum of Art, New York (37.43.10).*

45. Wooded landscape with country cart and figures. Black and coloured chalks on grey prepared paper, heightened with white. $9\frac{13}{16} \times 13\frac{1}{8}$ (249×333). Later 1770's. *Whitworth Art Gallery, University of Manchester (D.4.1931) (1508).*

46. Wooded landscape with country cart and figures (No.6). First state. Soft-ground etching. $9\frac{1}{4} \times 12\frac{11}{16}$ (235×322). Mid to later 1770's. *Ipswich Museum (1917–12.5).*

47. Wooded landscape with country cart and figures (No.6). Soft-ground etching with aquatint. $9\frac{7}{8} \times 12\frac{3}{4}$ (251×324). Mid to later 1770's. As published by J. & J. Boydell, 1 August 1797. *British Museum (Anderdon Edwards, f.296).*

48. Wooded landscape with figures and cows at a watering place (No.7). Soft-ground etching with aquatint. $9\frac{11}{16} \times 12\frac{13}{16}$ (246×325). About 1776–7. As published by J. & J. Boydell, 1 August 1797. *British Museum (1866–12-8–356).*

49. Wooded landscape with horseman. Black chalk and stump, water-colour and oil on reddish-brown prepared paper, varnished. $8\frac{3}{8} \times 11\frac{7}{8}$ (213×302). Later 1770's. *George D. Widener, Philadelphia.*

50. The Watering Place. Canvas. 59×72 (1499×1829). R.A. 1777. *National Gallery (109).*

51. Wooded landscape with mountainous distance. Black and white chalks on blue paper. $7\frac{1}{8} \times 8\frac{11}{16}$ (181×221). Later 1770's. *British Museum (1910–2–12–253).*

52. Wooded landscape with peasant and horses outside a shed. Pastel on grey paper. $9\frac{7}{8} \times 11\frac{7}{8}$ (251×302). Mid to later 1770's. *Tate Gallery (2227).*

53. Wooded landscape with peasant and horses outside a shed (No.8). Soft-ground etching. $11\frac{1}{8} \times 13\frac{3}{4}$ (283×349). Mid to later 1770's. *Courtauld Institute of Art, Witt Collection (2430).*

54. Wooded landscape with two country carts and figures (No.9). First state. Soft-ground etching. $11\frac{11}{16} \times 15\frac{1}{2}$ (297×394). 1779–80. *Henry E. Huntington Library and Art Gallery, San Marino.*

55. Wooded landscape with country cart. Grey wash. $10\frac{3}{8} \times 13\frac{3}{4}$ (264×349). Later 1770's. *Earl Spencer, Althorp.*

56. Wooded landscape with cottage, peasant, cows and sheep, and cart travelling down a slope. Black chalk and stump and white chalk on grey paper. $14\frac{15}{16} \times 12\frac{7}{16}$ (379 × 316). Later 1770's. *Mrs N. Argenti, London.*

57. Wooded landscape with two country carts and figures (No.9). Soft-ground etching. $11\frac{11}{16} \times 15\frac{1}{2}$ (297 × 394). 1779–80. As published by J. & J. Boydell, 1 August 1797. *Henry E. Huntington Library and Art Gallery, San Marino.*

58. Wooded landscape with peasant reading tombstone, rustic lovers and ruined church (No.10). First state. Soft-ground etching. $11\frac{11}{16} \times 15\frac{1}{2}$ (297 × 394). 1779–80. *Ehemals Staatliche Museen, Berlin–Dahlem (195–1913).*

59. Wooded landscape with peasant reading tombstone, rustic lovers and ruined church (No.10). Second state. Soft-ground etching. $11\frac{11}{16} \times 15\frac{1}{2}$ (297 × 394). 1779–80. *Henry E. Huntington Library and Art Gallery, San Marino.*

60. Wooded landscape with peasant reading tombstone, rustic lovers and ruined church (No.10). Soft-ground etching. $11\frac{11}{16} \times 15\frac{1}{2}$ (297 × 394). 1779–80. As published by J. & J. Boydell, 1 August 1797. *British Museum (47–7–13–48).*

61. *Maria Catharine Prestal (1747–94).* Wooded landscape with peasants reading tombstone and ruined church. Aquatint after Gainsborough. $18\frac{5}{16} \times 24\frac{13}{16}$ (465 × 630). Published by R. Pollard, 12 May 1790. *British Museum (1866–11–14–308).*

62. Country churchyard with two donkeys. Pencil. $6\frac{3}{16} \times 7\frac{3}{4}$ (157 × 197). Stamped in monogram. Later 1750's. *D.L.T. Oppé, London (1429).*

63. Wooded landscape with herdsman driving cattle over a bridge, rustic lovers and ruined castle (No.11). First state. Soft-ground etching, heightened with white. $11\frac{13}{16} \times 15\frac{1}{2}$ (300 × 394). 1779–80. *Ehemals Staatliche Museen, Berlin–Dahlem (197–1913).*

64. Wooded landscape with herdsman driving cattle over a bridge, rustic lovers and ruined castle (No.11). Second state. Soft-ground etching. $11\frac{13}{16} \times 15\frac{1}{2}$ (300 × 394). 1779–80. *Henry E. Huntington Library and Art Gallery.*

65. Wooded landscape with herdsman driving cattle over a bridge, rustic lovers and ruined castle (No.11). Soft-ground etching. $11\frac{13}{16} \times 15\frac{1}{2}$ (300 × 394). 1779–80. As published by J. & J. Boydell, 1 August 1797. *Davison Art Center, Wesleyan University, Middletown, Conn.*

66. Wooded landscape with herdsman driving cattle over a bridge, rustic lovers and ruined castle. Black chalk and stump and white chalk, with grey and grey-black washes. $10\frac{7}{8} \times 13\frac{1}{4}$ (276 × 337) (oval). About 1781. *Courtauld Institute of Art, Witt Collection (4181).*

67. Wooded landscape with herdsman driving cattle over a bridge, rustic lovers and ruined castle. Canvas. $48\frac{1}{4} \times 64\frac{1}{4}$ (226 × 632) (oval). R.A. 1781. *C. M. Michaelis, Rycote Park.*

68. Wooded upland landscape with horseman crossing a bridge and buildings. Black chalk and stump, with traces of white chalk. 10 $\frac{15}{16}$ × 14 $\frac{5}{8}$ (278 × 371). Mid-1780's. *Private collection, England.*

69. Wooded upland landscape with shepherd and sheep. Black chalk and stump and white chalk on buff paper. 10 $\frac{3}{16}$ × 14 $\frac{5}{16}$ (259 × 363). About 1787–8. *Tate Gallery (2223).*

70. Wooded landscape with country cart, cottage and figures (No. 12). Soft-ground etching. 9 $\frac{7}{8}$ × 12 $\frac{11}{16}$ (251 × 322). Mid-1780's. As published by J. & J. Boydell, 1 August 1797. *Henry E. Huntington Library and Art Gallery, San Marino.*

71. Wooded river landscape with shepherd and sheep (No.13). Soft-ground etching with aquatint. 9 $\frac{13}{16}$ × 13 $\frac{3}{8}$ (249 × 340). M id-1780's. *Tate Gallery (2720).*

72. Wooded landscape with riders (No.14). Aquatint. 7 $\frac{1}{4}$ × 9 $\frac{11}{16}$ (184 × 246). Mid-1780's. As published by J. & J. Boydell, 1 August 1797. *Metropolitan Museum of Art, New York (49.95.60).*

73. Wooded landscape with horsemen and figures. Black and brown chalks, grey and brown washes, and oil, varnished. 8 $\frac{7}{8}$ × 12 (225 × 305). Mid to later 1780's. *Courtauld Institute of Art, Witt Collection (1681).*

74. Wooded landscape with shepherd and sheep. Pen and brown ink and grey wash, varnished. 6 $\frac{15}{16}$ × 9 $\frac{3}{16}$ (176 × 233). Later 1760's. *From the collection of Mr and Mrs Paul Mellon, Oak Spring, Virginia (62/11/1/26).*

75. *Thomas Rowlandson (1756 or 1757–1827).* Wooded river landscape with figures, cottage and rowing boat. Soft-ground etching with aquatint after Gainsborough. 8 $\frac{15}{16}$ × 12 $\frac{3}{4}$ (227 × 324). Contained in *Rowlandson's Imitations of Modern Drawings, c. 1788. British Museum (M40–35).*

76. Wooded landscape with three cows at a pool. Grey wash, with touches of black, red and white chalk. 10 $\frac{1}{8}$ × 13 $\frac{5}{8}$ (257 × 346). Later 1770's. *Pierpont Morgan Library, New York (III, 63a).*

77. Wooded landscape with rocks. Grey and grey-black washes and white chalk on pale buff paper. 10 $\frac{7}{8}$ × 14 $\frac{1}{4}$ (276 × 362). Early 1780's. *Henry E. Huntington Library and Art Gallery, San Marino (57.1).*

78. Wooded landscape with three cows at a pool (No.15). First state. Aquatint, with grey wash added. 11 × 13 $\frac{5}{8}$ (279 × 346). Mid-1780's. *Ehemals Staatliche Museen, Berlin–Dahlem (188–1913).*

79. Wooded landscape with three cows at a pool (No.15). Aquatint. 10 $\frac{15}{16}$ × 13 $\frac{9}{16}$ (278 × 344). Mid-1780's. *Tate Gallery (2722).*

80. Wooded upland landscape with riders and packhorse (No.16). Mezzotint, with some use of drypoint. 9 $\frac{5}{16}$ × 12 $\frac{7}{16}$ (237 × 316). About 1783. As published by J. & J. Boydell, 1 August 1797. *Rijksmuseum.*

81. Wooded landscape with country cart and figures. Black and white chalks and grey and grey-black washes on buff paper prepared with grey. $9\frac{9}{16} \times 12\frac{11}{16}$ (243×322). Mid to later 1780's. *Mrs W. W. Spooner, Lullington.*

82. Wooded mountain landscape with shepherd, sheep and cows. Canvas. $46\frac{1}{4} \times 58\frac{1}{2}$ ($1,175 \times 1,486$). Signed. Autumn 1783. *Private Collection, U.S.A.*

83. Wooded landscape with figures on horseback and cottage. Grey wash and oil on brown prepared paper, varnished. $8\frac{1}{2} \times 12\frac{1}{4}$ (216×311). Early 1780's. *British Museum (G.g.3–392).*

84. Wooded landscape with figures, cottage and cow. Black chalk and grey and grey-black washes, heightened with white. $10\frac{1}{2} \times 15\frac{1}{4}$ (267×387). Later 1780's. *Richard S. Davis, New York.*

85. Wooded landscape with cows at a watering place, figures and cottage (No.17). Aquatint. $7\frac{1}{8} \times 9\frac{7}{16}$ (181×240). Mid-1780's. *Minneapolis Institute of Arts (3564) (The Ladd collection: gift of Herschel V. Jones, 1916).*

86. Wooded landscape with country cart and figures (No.18). Aquatint. $11\frac{1}{8} \times 13\frac{3}{4}$ (283×349). Mid to later 1780's. As published by J. & J. Boydell, 1 August 1797. *Henry E. Huntington Library and Art Gallery, San Marino.*

87. Wooded landscape with herdsman and cows (No.19). First state. Aquatint with soft-ground etching. $10\frac{1}{8} \times 12\frac{11}{16}$ (257×322). Mid to later 1780's. *Ehemals Staatliche Museen, Berlin–Dahlem (193–1913).*

88. Wooded landscape with herdsman and cows (No.19). Second state. Aquatint with soft-ground etching. $10\frac{1}{8} \times 12\frac{11}{16}$ (257×322). Mid to later 1780's. *With Christopher Mendez 1971.*

89. Wooded landscape with herdsman and cows (No.19). Aquatint with soft-ground etching. $10\frac{1}{8} \times 12\frac{11}{16}$ (257×322). Mid to later 1780's. As published by J. & J. Boydell, 1 August 1797. *British Museum (51–2–8–265).*

90. Wooded landscape with herdsman and cows (No.20). Aquatint. $11\frac{1}{16} \times 13\frac{3}{4}$ (281×349). Mid to later 1780's. As published by J. & J. Boydell, 1 August 1797. *Henry E. Huntington Library and Art Gallery, San Marino.*

91. Landscape with ploughing scene, windmill on a hill, and distant estuary. Canvas. 19×23 (483×584). Early 1750's. *Colonel S. L. Bibby, Epsom.*

92. Wooded landscape with cow standing beside a pool. Black and brown chalks and grey and grey-black washes, heightened with white. $9\frac{1}{2} \times 14\frac{11}{16}$ (241×373). Later 1780's. *Ehemals Staatliche Museen, Berlin–Dahlem (4666).*

93. Landscape with herdsmen, cows and horses. Black chalk with some stump, and white and coloured chalks, on blue paper. $11 \times 12\frac{9}{16}$ (279×319). Mid to later 1770's. *Nelson Gallery – Atkins Museum, Kansas City, Missouri (Gift of Thomas Agnew & Sons).*

94. Landscape with herdsman, cows, horses and trough. Engraving after Gainsborough published in *The Illustrated London News*, 25 July 1846. *The Illustrated London News*.

95. Landscape with herdsman, cows and horses. Canvas. 47×58 $(1,194 \times 1,473)$. Mid to later 1770's. *Nelson Gallery – Atkins Museum, Kansas City, Missouri*.

Biographical Outline

1727	Baptized on 14 May at the Independent meeting house in Friars Street, Sudbury, Suffolk, the fifth son of John Gainsborough, clothier, and Mary Burroughs.
c.1740	Sent up to London and became a pupil of Hubert François Gravelot, the French draughtsman and engraver.
c.1745	Established his own studio in London.
1746	Married Margaret Burr on 15 July at Dr Keith's Mayfair Chapel, London.
1748	Returned to Sudbury to practice. Birth of his elder daughter, Mary.
1752	Birth of his younger daughter, Margaret. Moved to Ipswich.
c.1753–4	Earliest etchings (Nos.1, 2 and 21).
1759	Moved to Bath.
1768	Invited to become a founder member of the Royal Academy.
1770's (*early*)	Earliest aquatint (No.3).
1772	Took his nephew, Gainsborough Dupont, as an apprentice.
1774	Settled in London, taking a tenancy of the west wing of Schomberg House, Pall Mall.
1770's (*mid to later*)	Early soft-ground etchings, mostly with aquatint (Nos.4, 5, 6, 7, 8 and 22).
1779–80	Series of major soft-ground etchings (Nos.9, 10 and 11).
c.1782	Made a tour in the West Country with Gainsborough Dupont.
c.1783	Constructed his peep-show box in which he displayed his transparencies.
1783	Made a tour of the Lakes with Samuel Kilderbee.
1780's (*mid*)	Soft-ground etchings, aquatints and mezzotint (Nos.12, 13, 14, 15, 16 and 17).

1784	Quarrelled with the Royal Academy about the hanging of his pictures, which he withdrew. Never again exhibited at the Academy, and started a series of annual exhibitions in his own studio.
1780's (*mid to later*)	Last aquatints (Nos.18 and 19).
1788	Died on 2 August, and was buried in Kew Churchyard.
1789	Private sale of his pictures and drawings held at Schomberg House. Further sales were held at Christie's in 1792, 1797 (following the death of Gainsborough Dupont) and 1799 (after Mrs Gainsborough's death).
1797	Set of twelve of his prints published by J. & J. Boydell on 1 August.

Gainsborough's Prints

Gainsborough may fairly be regarded as the greatest executant the British school has ever produced; or indeed, perhaps, is ever likely to. *What* he painted was always of less moment to him than *how* he painted, and anything relating to techniques or materials was a source of immediate excitement, though, as in his pursuit of musical proficiency, he was apt to be an impatient student. His processes of mind were intuitive, not rational. And his choice of methods both impulsive and unorthodox. There is the case of the drawings done at Bath of which an observer noted that 'a small bit of sponge tied to a bit of stick, served as a pencil for the shadows, and a small lump of whiting, held by a pair of tea-tongs was the instrument by which the high lights were applied';[1] no doubt, on other occasions, quite different materials or household implements were called into use. As Reynolds said, 'he neglected nothing which could keep his faculties in exercise, and derived hints from every sort of combination'.[2] His celebrated peep-show box, for instance, now in the Victoria and Albert Museum, in which he showed transparencies lit from behind by candlelight diffused through a semi-transparent screen, was directly inspired by contemporary experiments, in particular the moving pictures his friend de Loutherbourg had devised for an entertainment called the *Eidophusikon*, which took fashionable London by storm in 1781.

So there is certainly no cause for surprise to discover that even so busy a painter as Gainsborough undoubtedly was from 1760 onwards should become involved in the processes of printmaking. Nor that he should produce plates of marked originality and beauty, plates which increasingly impress one by their quality the more often one examines them. However, in studying the prints in detail, one should be cautioned by what one knows of his temperament and methods; the main processes may well be apparent, after careful examination, but to jump to conclusions about the minutiae of Gainsborough's technique, in the absence of firm internal or documentary

[1] Edward Edwards, *Anecdotes of Painters*, London, 1808, p.139.
[2] Sir Joshua Reynolds, *Discourse Fourteen*, 10 December 1788: *Discourses on Art*, ed. Robert R. Wark, San Marino, 1959, p.250.

evidence, would be more than unusually rash. An experienced printmaker might make intelligent guesses or suggest alternative possibilities for the production of this or that effect, but in the last resort such analyses must remain in the realm of conjecture. What follows, therefore, is an attempt to record all the known facts, to catalogue the various 'states' in existence (which has not been done before), and to assess Gainsborough's work as a printmaker on the basis of a new chronology. It has generally been assumed that his aquatints and soft-ground etchings, which make up the bulk of his *œuvre*, were produced in the earlier part of his career, and executed, more or less as a series, at one time.[3] Both assumptions are certainly wrong, and detailed arguments for dating the prints, based principally on Gainsborough's work in other media, are advanced in the relevant catalogue entries.

Gainsborough *did* etch in his early days, to be sure, but in the normal hard-ground technique; and it would perhaps be surprising if he had not done so, as he was brought up in the 1740's in a *milieu* of print production and book illustration. Indeed, his master Hubert Gravelot, indefatigable in the provision of drawings for engraving, was chiefly responsible for stimulating the development of both arts in England. It is possible that it was Gravelot who actually taught him to etch, but there is no evidence on this point. He may have taught others, as Vertue notes his teaching activity, stating that Grignion 'first learnt of Gravelot to draw and Engrave';[4] admittedly, etching is not mentioned, and on the subject of engraving Grignion himself said that 'Gravelot was a designer, but could not engrave. He etched a great deal in what is called the manner of Painters etchings, but did not know how to handle the graver.'[5] The disparaging reference to Gravelot as being a 'painter etcher', that is to say, one who confined himself to needling his plates, implies that he was unskilled in (or had no time for) the delicate processes of biting and printing. A number of Gravelot's etchings survive, among them his plates (some of them from his own drawings, some of them after Hayman) illustrating the 1742 edition of Richardson's *Pamela*; a few of these are rather lacking in sophistication, but others are delicate and accomplished (Pl.1). Gravelot may normally have given his 'needled' plate to an experienced

[3] See A. M. Hind, 'Notes on the History of Soft-Ground Etching and Aquatint', *The Print-Collector's Quarterly*, December 1921, p.381. Lumsden, however, stated that 'in all probability they were fairly mature works, (E. S. Lumsden, *The Art of Etching*, London, 1925, p.197). Friedländer was alone in assuming that they were late works (Max. J. Friedländer, 'Gainsborough als Radierer', *Kunst und Künstler*, September 1915, p.16).

[4] 'Vertue Note Books', Vol.3, *The Walpole Society*, Vol.22, 1934, p.130.

[5] *The Farington Diary*, 1 July 1806 (from the typescript in the British Museum Print Room, p.3342).

1 *Gravelot.* Etching from Richardson's *Pamela*, 1742.

assistant to bite, but there is no reason to suppose that he could not have taught Gainsborough to etch just as he instructed him in other matters.

At any event, as late as the early to mid 1750's, which is the date of Gainsborough's three known etched subjects (Nos 1, 2 and 21) and when he had had some eight or nine years' experience on his own, Gainsborough was still not entirely proficient (or else too hasty) in certain matters of technique. We know that the plate he produced for his friend Joshua Kirby's edition of *Dr. Brook Taylor's Perspective Made Easy*, published in 1754 (No.1), was finished for him by Wood; and in the case of another print (No.21), as we are informed by Edwards, 'he spoilt the plate by impatiently attempting to apply the aqua fortis, before his friend, Mr. Grignion, could assist him, as was agreed'.[6] However, Gainsborough's deficiencies were clearly in the processes of biting and printing rather than in the manipulation of the needle itself, for

[6] Edwards, op. cit., p.142. Aqua fortis was the name etchers used for nitric acid.

3

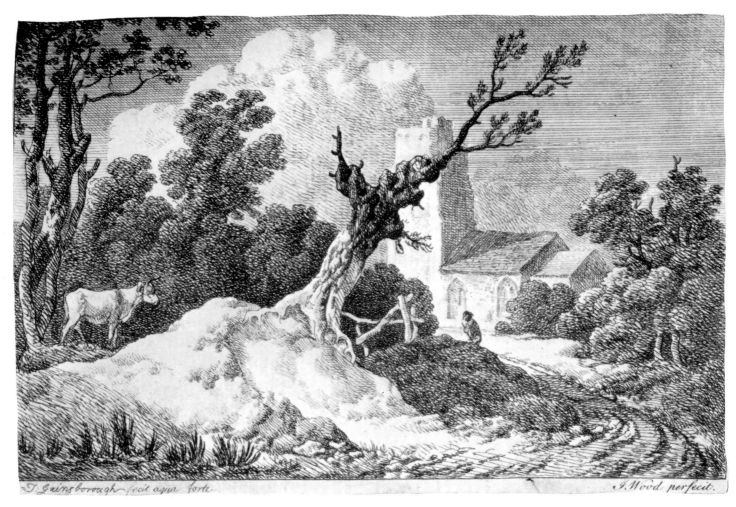

2 *Gainsborough*. Etching published 1754 (No.1).

his etching of the subject subsequently engraved as *The Gipsies* (No.2) was described by the Rev. Kirby Trimmer, in whose family had descended a great deal of Gainsborough's early work, as 'first-rate' – 'I merely mention this', he added, 'because he has been said to have failed in his etchings.'[7] Unfortunately, no impressions of either the subject he spoilt or his original etching of the gipsy encampment have yet come to light, so that our judgement of Gainsborough as a pure etcher must rest solely on the plate for Kirby's book (Pl.2). Curiously, in this instance, no fewer than three preliminary states survive, all of them with a provenance from Esdaile's collection.

This plate is firmly in the tradition of the mid-eighteenth-century British print; that is to say, in it Gainsborough sought to reproduce the effect of a picture rather than to exploit the medium itself. So, though it is remarkably

[7] Walter Thornbury, *The Life of J. M. W. Turner, R.A.*, London, 1862, Vol.2, p.59.

4

3 *Vivares*. Etching published 1739.

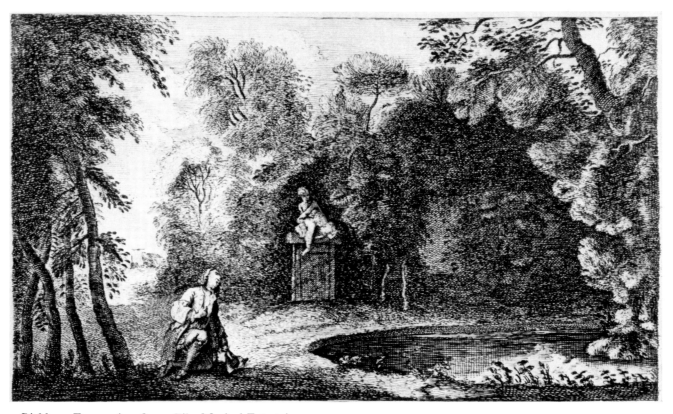

4 *Bickham*. Engraving from *The Musical Entertainer*, 1737–9.

accomplished, and compares favourably with the work of contemporary British practitioners, such as Vivares (Pl.3) or Bickham (Pl.4), there is no point of comparison with the work of Canaletto or Piranesi: or with the great Dutch etchers of landscape of the seventeenth century, Esaias and Jan van de Velde, Waterloo, Ruisdael, Rembrandt. Whereas in Gainsborough's work as a draughtsman there is, of course, contact in plenty with the Dutch tradition.

Weaknesses can be detected in parts of this plate: the scratchy touches in the area in shadow to the left of the bank are comparatively flat and meaningless, while the parallel lines in the sky on the extreme right have rather the effect of shooting the eye outside the composition. But generally, it is a very competent production, effectively composed in the familiar rococo idiom of his early period, and skilled both in the building up of forms, and the disposition of lights and darks – the suggestion of sunlight playing on the sandy bank is as brilliantly achieved here as in the finest of those early pencil drawings in which he essayed the same effects (Pl.31). It seems likely that the subject was one he had already used as a painting, though no such original has yet emerged.

Of Gainsborough's other two etchings, one (unless magnified for the purpose of engraving) was quite a large plate (No.2), and represented a subject we know he had rendered in paint in the period 1752–4. Both were probably done at roughly the same time as the plate for Kirby – and almost certainly on a visit to London from his home in Ipswich. Both Wood and Grignion, who assisted him, worked in London, and there is additional evidence that Gainsborough was in the capital at this time, as Nathaniel Dance later told Farington that before he went to Italy in 1755 he had been 'abt. 2 years with Hayman, as a pupil, where He became acquainted with Gainsborough.'[8] This was also the time when Major was busy engraving his view of *Landguard Fort* for Philip Thicknesse.

At the end of the 1750's Gainsborough was evidently contemplating a series of engravings, as a pencil drawing in the Witt Collection (Hayes 238) executed with the graver in mind is inscribed beneath: *Gainsborough fec. 1759* and marked with the number *1* (Pl.5). Another equally carefully delineated drawing, a mountain scene in pen and watercolour owned by Desmond Morris (Hayes 243), bears a similar inscription beneath: *Thomas Gainsborough*

[8] *The Farington Diary*, 6 January 1808 (from the typescript in the British Museum Print Room, p.3939).

6

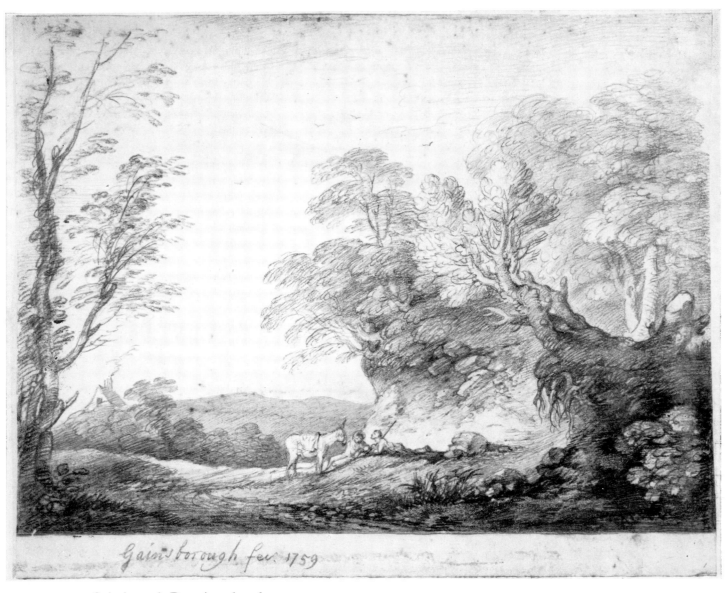

5 *Gainsborough*. Drawing dated 1759.

inv. et delineavit 1759. None of the prints seems to have been produced, but it is unlikely anyway that Gainsborough intended to engrave them himself.

One other pure etching must be noted at this point, an upright landscape with a shepherd looking after a flock of sheep which is inscribed bottom right: *Gainsbro 1760* (Pl.6). This work has puzzled commentators; it was accepted by Hind,[9] but Shaw Sparrow was rightly suspicious of it.[10] In style, it has nothing to do with anything by Gainsborough, even the figure being quite untypical, and there are no links of any sort with the earlier etchings dis-

[9] Hind, op. cit., p.381.
[10] Walter Shaw Sparrow, *A Book of British Etching*, London, 1926, p.196.

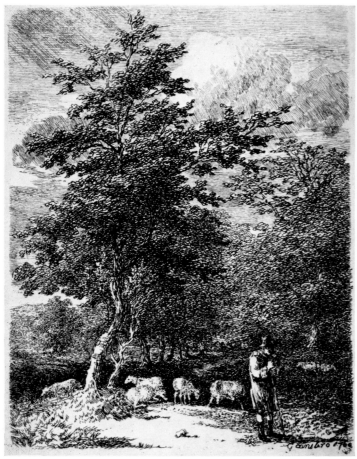

6 *Unidentified etcher*. Etching after Gainsborough.

7 *Sandby*. Detail from an etching published 1759.

cussed above; moreover, the form of signature is unusual. Curiously, comparison with the work of Paul Sandby reveals similar characteristics in his etchings of the late 1750's, for instance, in the modelling of the trees and the broken hatching in the clouds (Pl.7). It is not, however, sufficiently delicate or accomplished to be attributed to Sandby, and the most plausible explanation would seem to be that it is by an early nineteenth-century etcher working in the Sandby tradition, reproducing either a lost Gainsborough subject or a subject thought at the time to be by Gainsborough.

There is no evidence that Gainsborough occupied himself with printmaking again until the 1770's, when he became fascinated first by the possibilities of aquatint, and then by those of soft-ground etching, as a means of reproducing his drawings.[11] The fact that his purpose was reproductive

[11] The reproduction of old master drawings was already standard practice: *A Collection of Prints in Imitation of Drawings*, with critical notes by Charles Rogers, was published in two folio volumes in 1778, from plates executed in the 1760's and 1770's.

explains, of course, the close connection between his print style and his drawing style at any given moment, and provides a helpful basis for an accurate chronology of the prints. This was a period when reproductive processes which came close to 'imitation' preoccupied a number of artists and draughtsmen, partly for instructional purposes, for use in drawing-books, but largely for dissemination. However, as Friedländer pointed out, for an artist of the front rank to turn to etching solely as a means of reproducing his drawings is unprecedented in the whole history of engraving.[12]

What artists choose to disseminate is often a useful key to the heart of their style, and it is significant that the subjects Gainsborough chose for this purpose were entirely pastoral or elegiac in character, corresponding to the sentimental strain which predominated in his attitude towards life. What is difficult to explain is that hardly any of these prints seem to have been published in the artist's lifetime: new evidence to modify this conclusion would be a most welcome discovery. Of course, some of his work may have been wholly experimental, and the fact that he was sometimes prepared to use plates already worked on or quite badly scratched copper seems to indicate this; on the other hand, one of the subjects he did publish (No.10) was etched on a scratched plate.

Aquatinting was first developed in France by Jean Baptiste Le Prince in 1768 and 1769, and in the latter year Le Prince exhibited twenty-nine examples of the new process at the Salon; a short note in the catalogue explained that this was the most successful technique for reproducing wash drawings so far perfected. The basic principle was the use of a porous ground (composed either of dust produced from powdered resin or, more usually, resin dissolved in spirit which then evaporates), which, if bitten over the entire surface of the plate, would result in a mass of minute dots of even tone. The texture of the print, whether smooth or more granulated, depended on the composition of the ground. The design was created by an endless series of bitings with differing parts of the ground covered by a stopping-out varnish. An alternative to stopping-out, which was a negative way of proceeding, was provided by the sugar-lift formula. In this process the entire plate was first covered with stopping-out varnish and the subject was brushed in with a solution composed of sugar and Indian ink; the design was revealed on the plate when the solution lifted off after immersion in water.[13] This

[12] Friedländer, op. cit., p.16.
[13] A detailed modern account of the processes of aquatinting is contained in Anthony Gross, *Etching, Engraving and Intaglio Printing*, Oxford, 1970, pp.82–90.

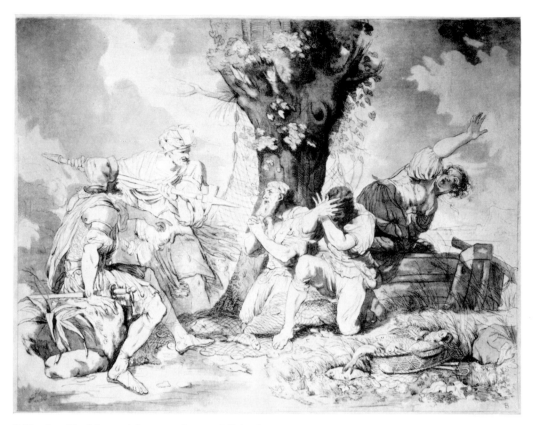

8 *Burdett.* Etching with aquatint published 1771.

9 *Sandby.* Aquatint from *Views in South Wales*, 1775.

10 *Gainsborough.* Aquatint with drypoint (No.3).

positive method of working made more of an appeal to painters, and was the one that Gainsborough most often used. Close examination of the prints also shows that Gainsborough normally used a dust ground for the production of his aquatint grain.

The earliest British artist to use the process was Peter Burdett, of Liverpool, who executed a subject piece after Mortimer with etched line and aquatint in 1771 (Pl.8), subsequently showing it at the Society of Artists in 1772, together with another which he entitled an 'Etching in imitation of a wash drawing'. But the man who really popularized this technique and first coined the term 'aquatinta' was Paul Sandby, whose earliest (very accomplished) aquatints – a series of views in South Wales (Pl.9) – were done in the summer of 1775. In September 1775 he wrote to John Clerk of Eldin: 'I perceive you have been trying at Le Prince's Secret, know my good Friend I got a key to it and am perfect master of it . . . these 4 months past I have scarcely done anything else.'[14] According to a note by Matthew Gregson, Sandby said he obtained the secret from Burdett, through the offices of his young pupil,

[14] Published in Martin Hardie, *Water-Colour Painting in Britain*, Vol.1, London, 1966, p.103. Sandby's own description of his technique is published in William Sandby, *Thomas and Paul Sandby*, London, 1892, pp.136–42.

the Hon. Charles Greville, who 'gave him forty pounds and he was (then run low in cash) to discover the art to him, which he did'.[15]

The question here is whether Gainsborough learnt the process from Sandby in 1775 or later – and he certainly knew Sandby quite well, and admired him[16] – or whether he learnt it from Burdett at an earlier date. The weight of evidence inclines to the latter view. His earliest aquatint, the group of three cows on a hillside (Pl.10), employs an etched outline, and has a quality of grain which is exactly like Burdett's work of 1771, and quite unlike Sandby's smoother more sophisticated, and at the same time more vigorous, work of 1775 (Pl.9). Moreover, the drawing for this aquatint dates from the earlier rather than the mid-1770's. One should also remember Gainsborough's usual impatience to learn a new technique (which he would surely have studied at the Society of Artists exhibition in 1772), and that in 1772 he himself had initiated a new imitative process, exhibiting drawings 'in imitation of oil painting' which a contemporary critic observed were 'handled with a *sportive* pencil, and shew the *versatility* of Mr. Gainsborough's genius'.[17]

Edwards said that Gainsborough 'attempted two or three small plates in aqua tinta, but was not very successful with them, as he knew little of the process'.[18] He was quite wrong in thinking that Gainsborough only did two or three small plates, and he made no mention of soft-ground etchings; nor has his judgement of the artist's technical deficiencies been supported by more modern critical opinion. Max Friedländer, who wrote an article[19] based on a study of the unrivalled series of prints and early states then recently acquired by the Berlin Kupferstichkabinett,[20] regarded Gainsborough's work (as revealed in the trial proofs) as astoundingly personal and audacious in technique, though a failure from the practical point of view, that is to say, in the material used for the plates, the biting, and the processes of inking and printing. This, he argued, was why Gainsborough soon abandoned print-making, why his contemporaries never acclaimed his achievement, and why Boydell's edition (see below) was a failure. It can now be shown that this

[15] Hind, op. cit., p.402.

[16] See, for example, Gainsborough's letter to Lord Hardwicke, dating from the early 1760's (Mary Woodall, *The Letters of Thomas Gainsborough*, 2nd ed. revised, London, 1963, No.42, pp.87 and 91).

[17] *The London Chronicle*, 5–7 May 1772.

[18] Edwards, op. cit., p.142.

[19] Friedländer, op. cit., pp.15–9.

[20] The provenance is given in Mary Woodall, *Gainsborough's Landscape Drawings*, London, 1939, p.94.

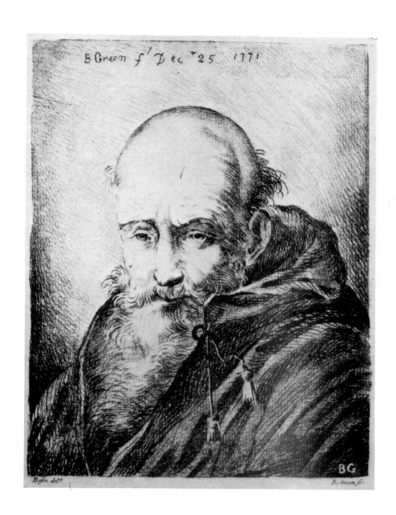

11 *Benjamin Green.*
Soft-ground etching after
Bossi, published 1771.

explanation is not the correct one; and Friedländer's strictures should have been reserved for Boydell. Criticism may be levelled at some of the prints, notably in Gainsborough's first phase, the work of the 1770's, but not of his work in pure soft-ground, nor of his increasingly experimental late style, which was diverse, assured and brilliant.

Mary Woodall, in the notes on his prints which she appended to her pioneer work on the landscape drawings,[21] suggested that Gainsborough actually initiated the practice of soft-ground etching. But there is no evidence to favour this view. The earliest plates in which Gainsborough used the process all date from the mid to late 1770's, while Benjamin Green, the drawing master of Christ's Hospital, is known to have done prints in soft-ground as early as 1771 (Pl.11). The medium was one particularly suited to

[21] Ibid., pp.93–8, which includes the first list of the prints to be compiled, numbering sixteen items.

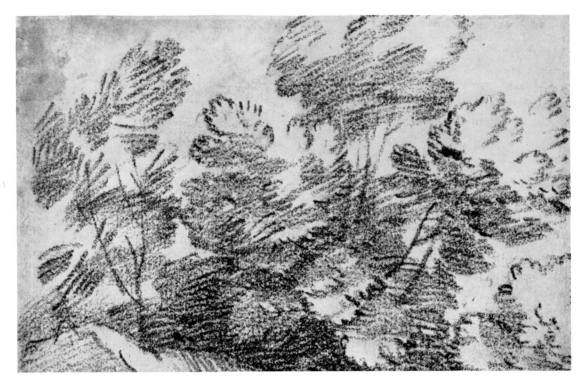

12 *Gainsborough.* Detail from Pl.46. Soft-ground etching (No.6). First state before aquatint.

13 *Gainsborough.* Detail from Pl.47. Soft-ground etching with aquatint (No.6).

the production of drawing books,[22] only being superseded with the invention of lithography at the end of the eighteenth century, and it is entirely conceivable that Green may have worked out the method.[22A] Once again, Sandby was among the first to adopt the new process, as an ancillary to aquatinting, and he described it in full detail in another letter to John Clerk of Eldin, written in about September 1775: 'put the dabber into the Tallow, and dab the Etching ground well all over while the plate is hot, when you have lay'd it pretty eaqual and thin, smoke it as usual, when the plate is cold lay some thin post paper over it, taking care not to bruise the ground by pressing too hard. Draw your design or view with a black lead pencil, which will press thro' the ground and lay the out line bare to the copper which you may bite in with Aquafortis to what strength you please . . . it saves all the trouble of Etching with a needle, and will produce an outline like fine Italian Chalk.'[23]

Soft-ground harmonized admirably with the textures of both smooth and granulated aquatint, and in most of his prints of the mid and later 1770's Gainsborough combined the two processes. His procedure was first to rough out a subject in soft-ground, as may be seen from an early state of his landscape with a country cart (Pls 46 and 12), and then to enrich the modelling with much darker tones, achieving the effect of stump work with the aid of a punch (Pls 47 and 13). Some of his experiments of this period are not entirely successful, as, for instance, the composition with three cows at the far side of a pool (Pl.41), which has some rather finicky hand-corrections. On the other hand, *The Watering Place* (Pls 48 and 14) can surely claim to be one of Gainsborough's best plates. The effect of black chalk is obtained with particular success in the trees on the left, where occasional touches of the roulette are used to simulate stump, and the areas of coarse grey-black soft-ground greatly enhance the massiveness of the tree forms, equating them with drawings such as that in the Widener collection (Pl.49). The middle tints in

[22] Many of Green's soft-ground etchings are reproductions of drawings by Salvator Rosa, Pillement and others; but an undated *Drawing Book of Landscapes* is in the British Museum (1896–12–30–148). A biographical account and list of his extant work is contained in the catalogue of *The Green Exhibition*, Halesowen, October 1951 (a copy was kindly lent to me by Mr Ian Fleming-Williams).

[22A] It has recently been shown that the process was actually invented in the seventeenth century, by Castiglione (Anthony Blunt, 'The invention of soft-ground etching: Giovanni Benedetto Castiglione', *The Burlington Magazine*, August 1971, pp.474–5). But there is no indication that it was ever exploited, and it seems likely that it was worked out afresh in the later eighteenth century rather than that Green or others were directly influenced by Castiglione, though this is of course perfectly possible.

[23] Hardie, op. cit., p.103. The process was capable of producing lines similar to pencil or chalk as desired, by varying the strength of biting. See also, for a succinct account of the process with illustrations, William M. Ivins, Jr., *How Prints Look*, Boston, 1958, pp.106–7.

14 *Gainsborough*. Detail from Pl.48. Soft-ground etching with aquatint (No.7).

the foliage, where the sugar-lift method of aquatinting has been employed, are evidently produced by the pen. In all parts of the composition soft-ground and different types of aquatint are used with great skill as complementary media.

Then in a series of prints produced in about 1780 Gainsborough abandoned aquatint and concentrated on the soft-ground process. Three at least of these prints (Nos 9, 10 and 11) were intended to be published as a series, and are in fact the only examples of Gainsborough prints which we know to have reached or neared the stage of publication in the artist's lifetime. In the case of this series, a few of Gainsborough's own pulls can be identified with certainty. There are two impressions of the landscape with country carts and figures (No.9) and single impressions of the other two prints, all of them, however, trimmed to the subject, so that the publication line is missing.

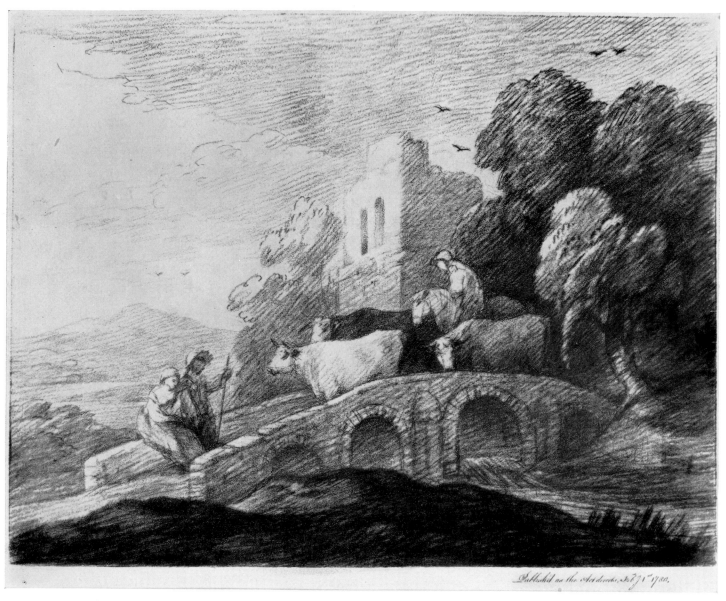

15 *Gainsborough.* Soft-ground etching (No.11). Second state, 1780.

Fortunately, untrimmed proof impressions of all three subjects are preserved in the Henry E. Huntington Art Gallery (Pls 54, 59 and 15). Each of these is lettered: *Publish'd as the Act directs, Feb.ʸ 1ˢᵗ 1780*, followed by a word (or words) of eight or nine letters length which have been erased and cannot be distinguished; one is also inscribed: *Tho.ˢ Gainsborough fecit* (Pl.59). They are superbly printed on laid paper, which seems to have been Gainsborough's usual practice²⁴ (many of the impressions later published by Boydell were not). There is no doubt from these powerful impressions that these subjects

²⁴ All the early states known are printed on laid paper.

17

were among Gainsborough's finest plates. They are by far the largest of Gainsborough's prints, and two of them represent subjects also carried out in oil, which were among his most important Academy exhibits of 1780 and 1781. Gainsborough was making a special effort to popularize his landscapes at this time,[25] and it is probable that the prints were intended as part of this programme.

The line may not possess quite the vigour of the combined soft-ground and aquatint of *The Watering Place*, but this is clearly intentional, for instead there is a certain softness of effect, the development of which can be most easily studied by comparing the first state of *The Country Churchyard* (Pls 58 and 16) with the second (Pls 59 and 17). The result is a perfect equivalent of the particular type of black chalk drawings Gainsborough was doing at the beginning of the 1780's (Pl.18), and the change from the combined media to pure soft-ground in fact paralleled, and may well have been the result of, this change of emphasis in his drawing style. The trees are bushier and more rhythmically conceived than in *The Watering Place*, and the compositions are characterized by a majestic fullness and sweep; the way in which the trees, the figures and the wall are all enveloped in one great curve in the church-yard scene is even more dramatic than the similar descending cadence of the landscape with cattle being driven across a bridge. The rhythmic vitality characteristic of this group is, if possible, even more pronounced in two later soft-grounds, the river scene with distant mountains (Pl.71) and the land-scape with country cart and cottage (Pl.70), which are also truer in their translation of the actual texture of soft black chalk. It was perhaps natural that this preoccupation with softness of effect should lead Gainsborough to try his hand at mezzotint,[26] and the only instance of his use of this medium dates from this period (Pl.80).

Later he began to experiment once again with aquatint, this time for the most part without any or very little admixture of soft-ground, for nothing but aquatint could satisfactorily render the brilliant light effects, dramatic silhouettes and turbulent skies of his late wash drawings and oil sketches. The recently discovered subject in Minneapolis (Pl.85) is an admirable example of his strength of lighting and his broken skies, and the landscape with cows being driven home (Pls 88 or 89) of his lively silhouetting of the shapes of trees and foliage against a sunset sky. In the latter case, Gains-

[25] See my article on 'Gainsborough's Later Landscapes', *Apollo*, July 1964, pp.20–6.

[26] Dupont started mezzotinting the more important of his uncle's portraits in 1779, so that experience in this field was at Gainsborough's elbow. Possibly he helped in the execution of this print.

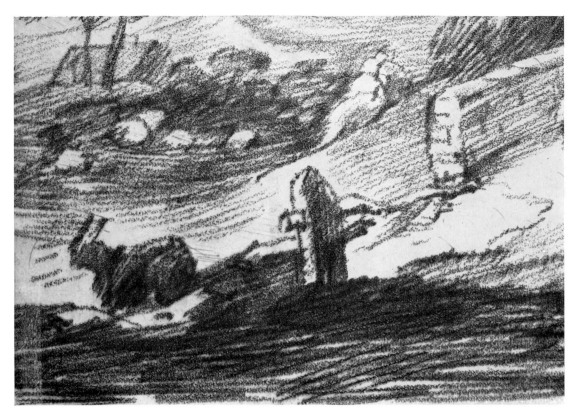

16 *Gainsborough*. Detail from Pl.58. Soft-ground etching (No.10). First state.

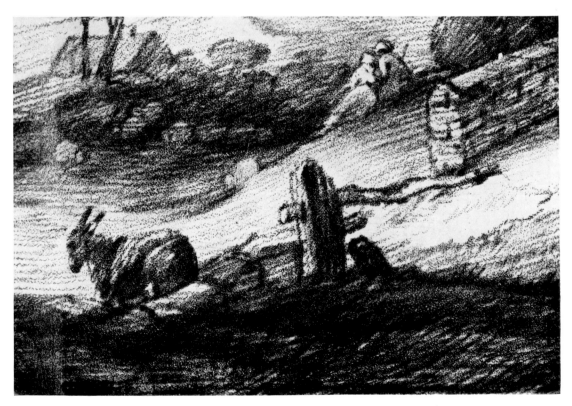

17 *Gainsborough*. Detail from Pl.59. Soft-ground etching (No.10). Second state, 1780.

18 *Gainsborough.* Detail from Pl.54. Soft-ground etching (No.19). First state, 1780.

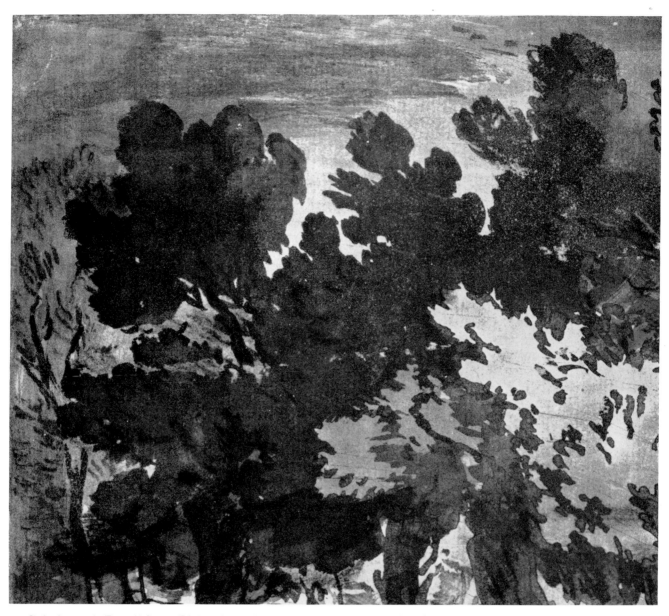

19 *Gainsborough*. Detail from Pl.87. Aquatint with soft-ground etching (No.19).

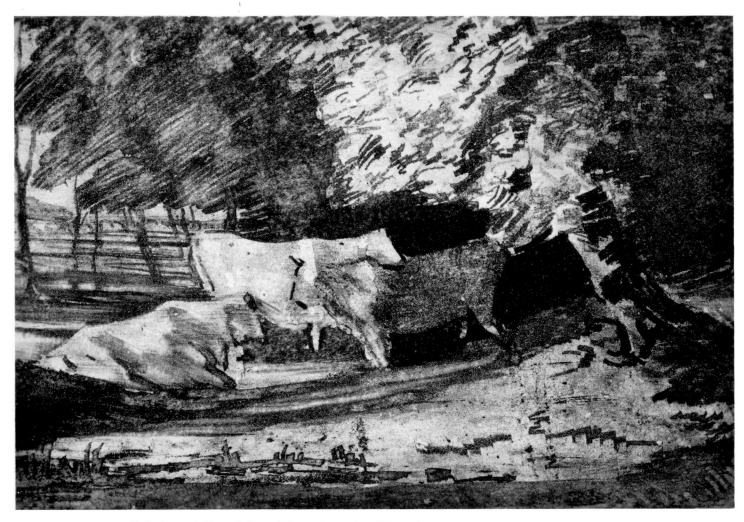

20 *Gainsborough.* Detail from Pl.90. Aquatint (No.20).

borough enriched the modelling of the forms with a considerable amount of soft-ground; but the first state (Pls 87 and 19), which is almost pure aquatint, in fact achieved all the spontaneity and freshness of wash. This trial proof is considerably more subtle in modelling and in its variety of tones (the foliage top right is especially unsuccessful in the final version), and may rank amongst Gainsborough's most brilliant achievements in the field of print-making. It seems likely that in some cases (compare Pls 78 and 79) Gainsborough may only have outlined his composition on the plate first, adding wash on a trial proof to indicate the precise balance of light and shade he proposed to follow.

In one of his last works, the wooded landscape with cows (Pl.90), Gainsborough blocked out the forms in the manner characteristic of his brilliant late wash drawing in Berlin (Pl.92), and endowed the composition with a certain ruggedness unusual in his prints (Pl.20). In the landscape with a

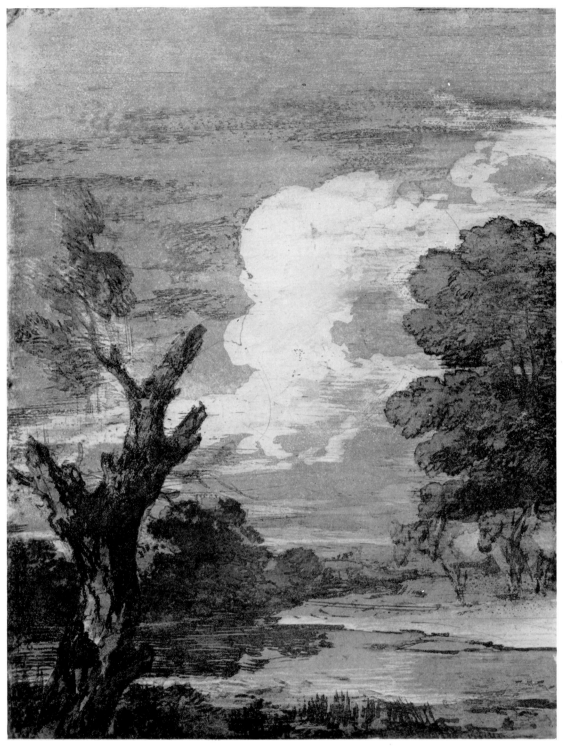

21 *Gainsborough*. Detail from Pl.86. Aquatint (No.18).

country cart (Pl.86), a variant, in reverse, of a much earlier subject, he achieved an extraordinary delicacy and richness in the modulation of tones (Pl.21), and here, once again, we are in the presence of greatness. Prints such as these, still in fact reproductive – imitations of drawings – are in quite a different class from most late eighteenth-century work, and stand at the beginning of a more original tradition in British printmaking which was to include the names of J. R. Cozens (Pl.22), Blake, Crome, J. S. Cotman (Pl.23), Constable and Turner. One is tempted to go further, and to say that they are prints which Goya himself might intensely have admired.

In judging the quality of Gainsborough's prints, it must, of course, be borne in mind that most of the examples familiar to us were published after the artist's death, by Boydell. Friedländer certainly exaggerated in calling them dull, but one has only to compare Gainsborough's own pulls (where such exist) with one of these later impressions (Pls 54 and 57 or 64 and 65) to appreciate the deficiency of Boydell's printing. In fact, it seems to have been customary, even among members of the Gainsborough family, to strengthen the effects of the prints with chalk.[27] It has been suggested that the plates themselves were made of a softer metal than copper, either zinc[28] or pewter,[29] which would have contributed towards premature wear, but this is not so.

There is no evidence as to where Gainsborough actually carried out his experiments in printmaking. He seems not to have possessed a printing press himself (as we know, for example, that Rowlandson did), since no such apparatus was among his studio effects; and, in view of the limited number of prints he produced, it is most likely that he used a friend's equipment.

Boydell's publication of the prints, a seemingly hazardous venture when seen in the context of the low prices fetched by Gainsborough's work at the big studio sale of April 1797,[30] is dated 1 August 1797. However, the set may

[27] 'Three etchings of landscapes, touched upon and heightened with white chalk' were in the Henry Briggs sale, Christie's, 25 February 1831, Lot 102.

[28] Friedländer, op. cit., p.16.

[29] George Williams Fulcher, *Life of Thomas Gainsborough, R.A.*, London, 2nd ed., 1856, p.245, without giving evidence; see also Mrs Arthur Bell, *Thomas Gainsborough*, London, 1897, captions to illustrations facing pp.12, 13, and 14 (the illustration facing p.13 is actually of a wash drawing, not a print). A group of prints presented to Sir J. L. (conceivably Sir John Leicester) by Margaret Gainsborough (not Mrs Gainsborough, as inscribed) in May 1818 (Anon. sale, Sotheby's, 22 July 1971, Lots 220–7) are inscribed as 'from Pewter Plates', so that the tradition seems to be an early one, deriving from Gainsborough's daughter.

[30] Gainsborough Dupont sale, Christie's, 10–11 April 1797; the dealer Vandergucht told Farington some years before that 'the pictures of Gainsborough are decreasing in value. The raging fashion of collecting them subsiding fast' (*The Farington Diary*, 15 July 1794: from the typescript in the British Museum Print Room, p.196).

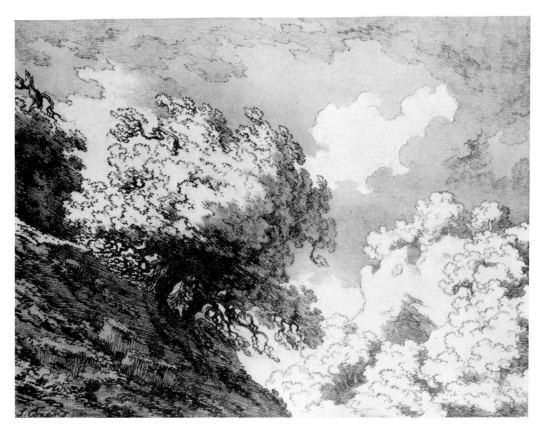

22 *J. R. Cozens.* Soft-ground etching.

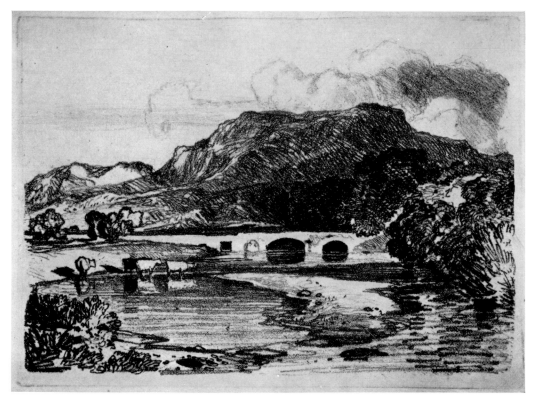

23 *J. S. Cotman.* Soft-ground etching. Artist's proof.

not actually have appeared until June 1798, when *The Monthly Magazine* advertised it as a new publication: 'Etchings, by the late Mr. Gainsborough. Twelve Prints of Landscape Scenery, with cattle and figures; the plates have never been worked upon by any other artist.'[31] They can be distinguished by the fact that each is numbered, though in some impressions the number has been deliberately erased. Six of the series were published with the number in the top left corner, and the letterpress on a separate plate (Pl.57); and the remaining six with wide margins, the number being placed outside the composition, and the letterpress within the plate (Pl.70).[32] All were printed both in grey and brown. One or two impressions exist on blue paper. Coloured paper was commonly used at the time, but in the case of the Gainsborough prints, it was not a success, and Boydell must have abandoned the experiment.

Boydell's edition cannot have been large, to judge by the scarcity of these prints, but it must have attained at least a moderate success, as Wells and Laporte followed Boydell's initiative and embarked on an even more ambitious enterprise in January 1802, the reproduction of seventy-two of Gainsborough's drawings in soft-ground etching, as a series of prints illustrative of English scenery. Boydell's disposal of the plates in this very same year had nothing to do with the popularity or otherwise of Gainsborough, but reflected the general state of his own finances – a final catalogue of his stock was issued in 1803, and some of his plates were auctioned in January of that year.[33] In connection with the sale of the Gainsborough plates, there is an interesting unpublished letter of Margaret Gainsborough's in the Ipswich Museum, dated from Brook Green, Hammersmith, 6 April 1802, in which she wrote to the man who was probably Boydell's manager in Cheapside: 'M^iss Gainsboroughs Comp^ts to M^r Harrison, begs to inform him that the Plates by her father are to be sold by Auction by M^r Christie and therefore shou'd be much oblig'd to him to let all the Prints from those Plates be sent to the Shakespear, and give an order to have them delivered to her when call'd for, likewise what Miss Parr has – M^iss G. will call and settle with M^r Harrison very soon.'[34] They were not in fact sold at Christie's, or at the

[31] *The Monthly Magazine*, June 1798, p.455.

[32] The latter group, with the exception of the mezzotint (No.16), all have distinctly sharper lines bordering the subject. This applies also to Nos.4, 13, 15, and 17 not in the Boydell series.

[33] Anon. (=Boydell) sale, Wells, 26–7 January 1803 (Lugt 6545).

[34] Harrison may possibly have been from James Harrison & Co., booksellers of 108 Newgate Street (Holden's *London Directory*, 1802). The only other Harrisons who might have stocked prints listed in 1802–3 were Harrison & Cooke, wholesale stationers of 5 Leadenhall Street and Harrison & Stubbs, stationers of 82 Cornhill. More probably, however, he was Boydell's manager at 90 Cheapside. He was certainly the Boydells' successor at that address, as he is described as such in the advertisement

1803 sale, or elsewhere at auction, so far as it is possible to discover; and it seems likely that they were sold privately. Either then or later they were acquired by the plate printing firm of McQueen, then established at No.72 Newman Street, St Marylebone. Eleven of the plates still survive, and until their recent purchase by the Tate Gallery, they were in the possession of Thomas Ross and Son,[35] which merged with McQueens in the present century; all these are in excellent condition and they seem to have lain untouched, as they show little or no deterioration since the time of Boydell.

In conclusion, a word about Rowlandson's etchings after Gainsborough may be useful, as confusion has sometimes arisen between these prints and Gainsborough's own (one even crept into Mary Woodall's list) (Pl.24).[36] Rowlandson, who must have known and greatly admired Gainsborough,[37] etched a number of plates after his landscapes in soft-ground and aquatint. Five of these he included in his *Imitations of Modern Drawings*;[38] and a further four in a slightly different technique, from drawings then in the collection of C. F. Abel, were published by John Thane in May 1789 (Pl.25).[39] The latter group should present no problem, unless the impressions are trimmed, as the letterpress is explicit enough. But the former is a different matter, as each

of the Boydell sale, Robert H. Evans, 1 June 1818 ff. (Lugt 9402). Miss Parr was almost certainly a member of the firm of M. Parr, printseller and frame-maker of 52 Pall Mall (Holden, op. cit.), the same address as Boydell's Shakespeare Gallery.

[35] Iain Bain, 'Thomas Ross & Son', *Journal of the Printing Historical Society*, No.2, 1966, p.21. I owe this vital reference to Robert Wark, in whose company I inspected the plates in 1967. Iain Bain is now preparing a limited edition of these eleven subjects. Two of the plates are marked 'Jones & Pontifex, 47 Shoe Lane' and one is marked with the name 'Guerre'. Unfortunately, neither of these pieces of information helps in dating the plates and thus the prints. Examination of the London Directories from 1765 to 1798 preserved in the Guildhall Library does not reveal the firm of Jones & Pontifex, coppersmiths of 47 Shoe Lane, as operative until 1790 (and then only in the larger Directories), and the firm of Guerre does not occur at all. It should be emphasized that late eighteenth-century Directories were by no means comprehensive in their listing.

[36] Woodall, op. cit., p.97, No.7. One was exhibited as Gainsborough as recently as this year: *Shock of Recognition*, Arts Council, Tate Gallery, January–February 1971, No.37.

[37] See my *The Drawings of Thomas Gainsborough*, London, 1970, Vol.1, p.84.

[38] This series, produced in about 1788 (on internal evidence) was apparently published in plain grey wrappers: a unique copy is recorded (see Bernard Falk, *Thomas Rowlandson: His Life and Art*, London, n.d.=1949, p.209). Sets bound up later, with differing numbers of plates, survive in various libraries today, e.g. in the British Museum Print Room, where the copy (166.d.9) contains thirty-five plates (including ten after Rowlandson's own drawings).

[39] One of these is reproduced in Hind, op. cit., facing p.381. Rowlandson (or his publisher Thane, who is known to have possessed at least one Gainsborough drawing himself) had been quick to take advantage of the market. Gainsborough's pictures and drawings were then on view at Schomberg House, and *The Diary* had noted on 13 April 1789 that "it would be a great acquisition, and tend highly to improve drawing, were a few of Mr. GAINSBOROUGH's beautiful chalk sketches consigned to *Earlom* for *aqua tinta* etchings. Such a plan would infinitely repay the expence of the undertaking.'

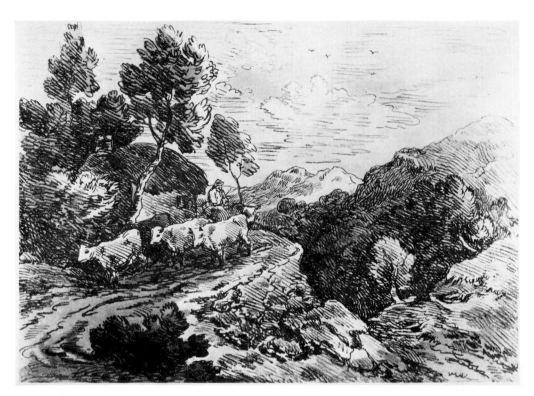

24 *Rowlandson*. Soft-ground etching with aquatint after Gainsborough, from *Imitations of Modern Drawings*, *c*.1788.

25 *Rowlandson*. Soft-ground etching with aquatint after Gainsborough, published 1789.

print is labelled 'Gainsborough' and nothing else; this, however, actually refers to the original from which it was taken, the names of Mortimer, Barret, Wheatley and so on appearing in connection with other plates in the series. Careful comparison of Rowlandson's style with even the most *mouvementé* of Gainsborough's etchings should, however, soon dispel any doubts. Rowlandson used a much thicker contour line, and was more summary in the description of forms, often regarding rapid squiggles as adequate notation; his line was also more vigorous than anything in Gainsborough, the trees and foliage seeming to possess an extraordinary inner vitality personal to Rowlandson (Pl.75). Rowlandson's imitations are almost a parody of Gainsborough's rococo, and should be very easily recognizable when they appear as loose plates.

Catalogue

Since many of the prints were never published, and most of the remainder were first issued as a set some time after Gainsborough's death (August 1797), they are catalogued in order of execution rather than by date of publication. The sizes given are those of the plates, with the composition sizes in brackets; where no brackets occur, the composition size can be assumed to be identical with the plate size. Height precedes width. For the convenience of interested students, all impressions known to the author contained in public collections (including the Mellon Collection) are listed in the catalogue. These lists, and the references cited, are as far as possible complete as at 31 July 1971. The bibliographical notes do not include references in Museum or sale catalogues and bulletins, unless they affect our knowledge or understanding of the prints. The following abbreviations have been employed:

Hayes=John Hayes, *The Drawings of Thomas Gainsborough*, London, 1970.

Waterhouse=Ellis Waterhouse, *Gainsborough*, London, 1958.

Woodall=Mary Woodall, *Gainsborough's Landscape Drawings*, London, 1939.

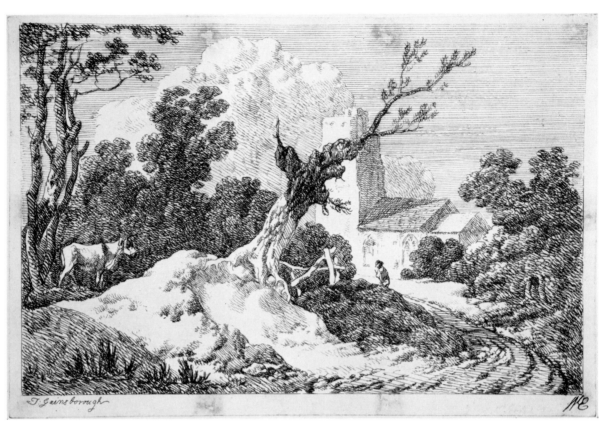

26 Etching (No.1). First state.

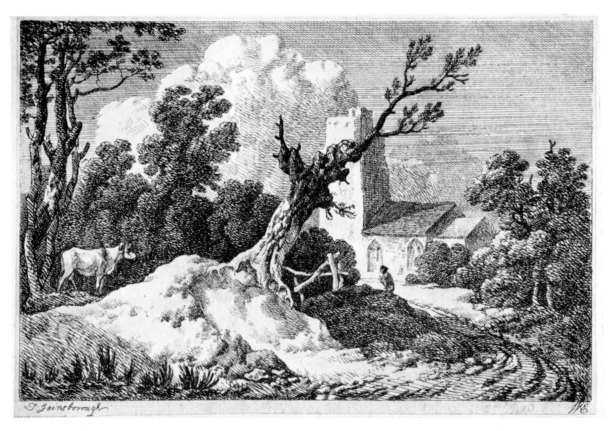

27 Etching (No.1). Second state.

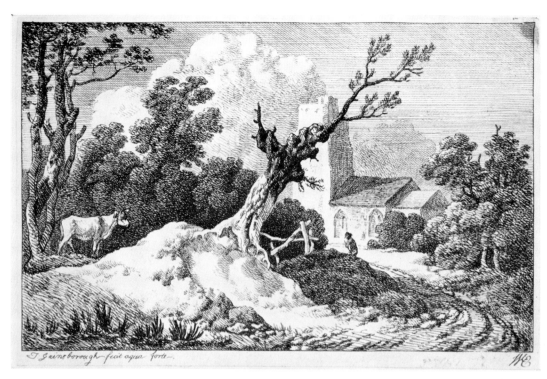

28 Etching (No. 1). Third state.

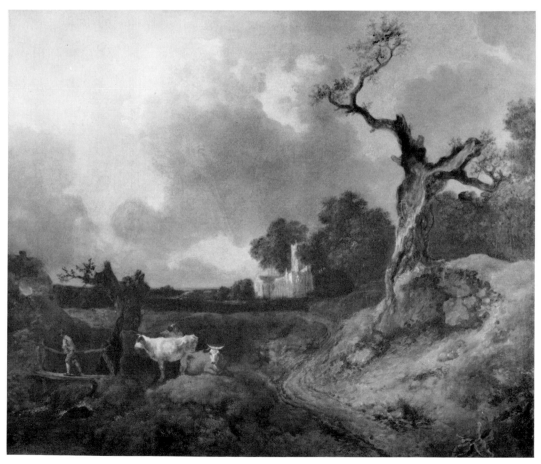

29 Painting.

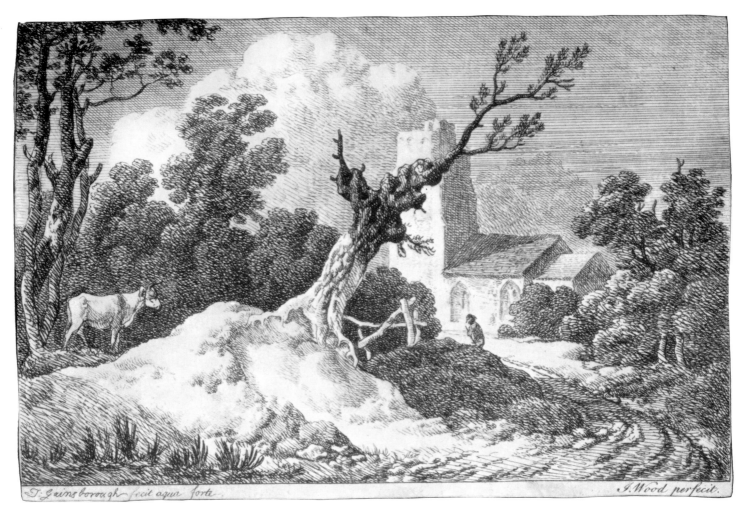

30 Etching published 1754 (No.1).

1 Wooded Landscape with Church, Cow and Figure

1753–4

Etching. 4 $\frac{15}{16}$ × 7$\frac{1}{2}$ (3 $\frac{15}{16}$ × 6$\frac{1}{8}$); 125 × 191 (100 × 156).
Inscribed: *T: Gainsborough fecit aqua forte* and *J. Wood perfecit.*

A trimmed impression of the finished print is in the British Museum (1878–12–14–158) (Pls **2** and **30**).
Published by Joshua Kirby in his *Dr Brook Taylor's Method of Perspective Made Easy*, Ipswich, 1754, fig.72.

First state: without the dark cloud right, various small branches in the trees, the hatching in the fencing centre, and the cross-hatching in the bank, the main tree trunk left and especially the sky; signed, but otherwise without letters (Glasgow University Collection) (Add.831) (Pl.**26**).

Second state: with the composition almost finished; signed, but otherwise without letters (Glasgow University Collection) (Add.832) (Pl.**27**).

Third state: with some additional cross-hatching in the sky top left, and the words *fecit aqua forte* added (Glasgow University Collection) (Add.833) (Pl.**28**).

BIBLIOGRAPHY: Edward Edwards, *Anecdotes of Painters*, London, 1808, p.142; Woodall, p.94.

Executed in hard-ground etching, and finished by Wood. The print has a loose relationship to the landscape painting dating from the same period in the Bowes Museum (Waterhouse 852) (Pl.**29**), insomuch as similar motifs are disposed in a different way. The original drawing, now lost, may be identified with the *Landscape and Figures, with View of a Village Church, (black lead pencil)* in George Baker's sale, Sotheby's, 16 June 1825 ff., 3rd Day, Lot 355 (two etchings from this drawing, perhaps identifiable with those now at Glasgow, were sold in the same lot). It is perhaps worth noting that a copy of this print was made by the youthful Turner (Pl.**32**): it is contained in a sketchbook in the Princeton Art Museum inscribed as 'left at – / Mr Nureaways (sic) – Bristol / about 1790 or 1791–.'

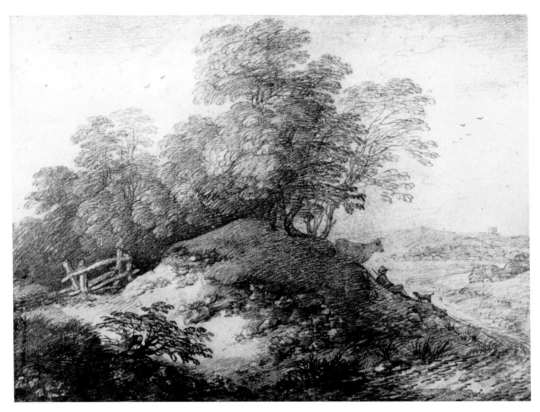

31 Drawing.

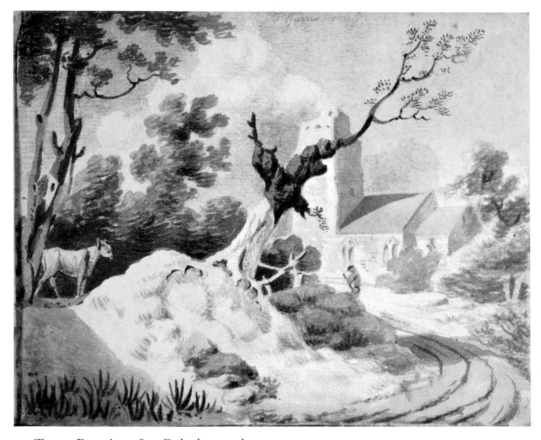

32 *Turner*. Drawing after Gainsborough.

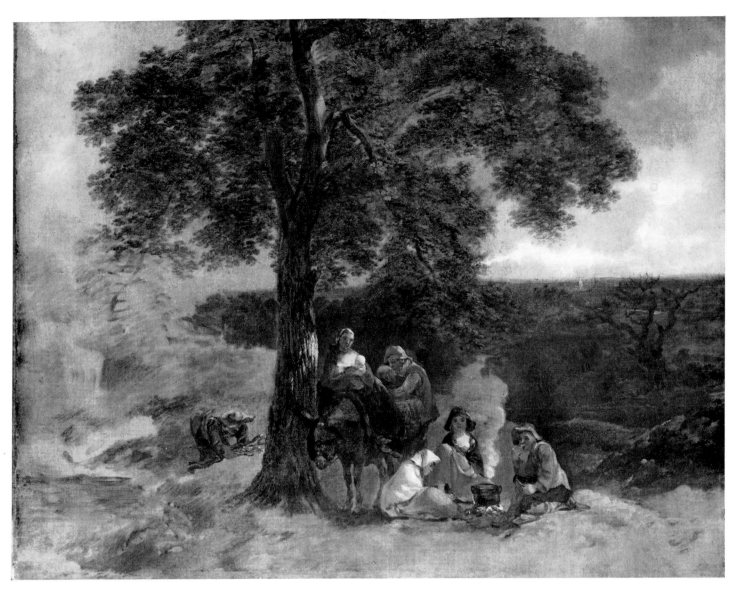

33 Painting.

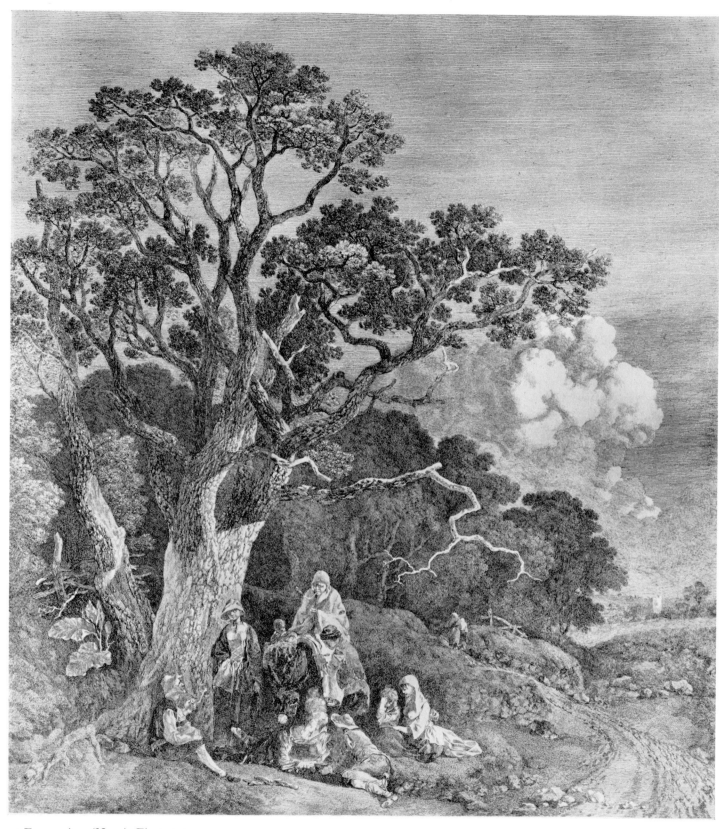

34 Engraving (No.2). First state.

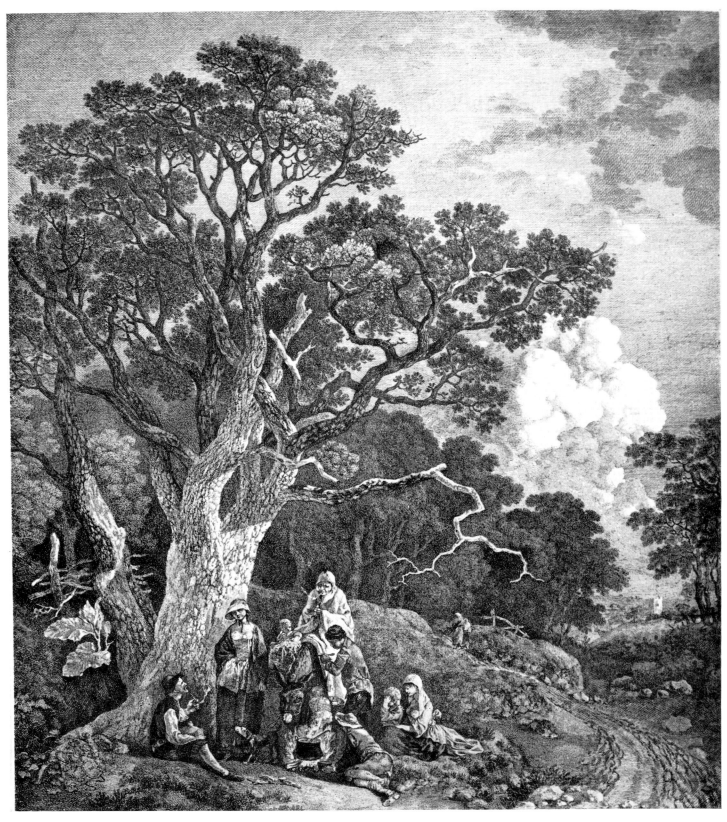

35 Engraving (No.2). Second state.

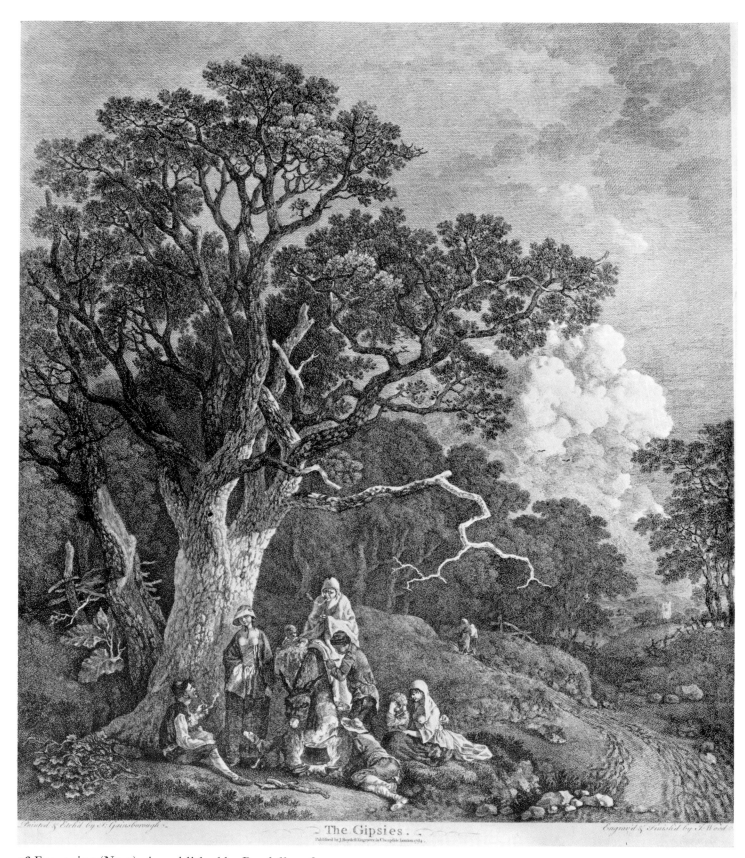

Painted & Etch'd by T. Gainsborough. The Gipsies. Engrav'd & Finish'd by J. Wood.

Published by J. Boydell Engraver in Cheapside London 1764.

36 Engraving (No.2). As published by Boydell, 1764.

40

2 Wooded Landscape with Gipsies round a Camp Fire (The Gipsies)

1759 (the original etching probably about 1753–4)

Engraving. 19⅝ × 17 11/16 (18 9/16 × 16½); 498 × 449 (471 × 419). The copper plate was in the Boydell sale, Robert H. Evans, 1 June 1818 ff. (Lugt 9042), 3rd Day, Lot 82. Inscribed: *Painted & Etch'd by T : Gainsborough* and *Engrav'd & Finished by J : Wood.*

Impressions of the finished print dated March 1759 are in the Philadelphia Museum of Art, and at Christchurch Mansion, Ipswich. Impressions dated 1764, when the subject was republished by J. Boydell, are in the British Museum (1866–11–14–310 (Pl.**36**) and 1912–6–27–2) and the Fogg Art Museum.

First state: without the branch bottom left, the trees and fencing right, the two birds, the clouds top right, and the cross-hatching; without letters (British Museum 1877–6–9–1774) (Pl.**34**).

Second state: without the birds and some of the cross-hatching; without letters (National Museum of Wales) (trimmed) (Pl.**35**).

BIBLIOGRAPHY: Edward Edwards, *Anecdotes of Painters*, London, 1808, p.142; Walter Thornbury, *The Life of J. M. W. Turner, R.A.*, London, 1862, Vol.2, pp.59–60; Walter Shaw Sparrow, *A Book of British Etching*, London, 1926, pp.195–6; Woodall, p.94.

The painting from which this print was made was executed for an Ipswich client but has never come to light (Waterhouse 887). The first (unfinished) version of the picture, slashed by Gainsborough in a temper, and afterwards given to his friend Joshua Kirby, dates from about 1752–4. It is now in the Tate Gallery (5845) (Waterhouse 864) (Pl.**33**). No impressions of the original etching by Gainsborough are now known, but one was in the possession of the Rev. Kirby Trimmer in 1862, and described by him as 'first-rate' (see Thornbury, op. cit., p. 59). When the engraving was republished by Boydell in 1764, it was issued as a companion to Wilson's *Lake Nemi* (then at Stourhead), also engraved by Wood.

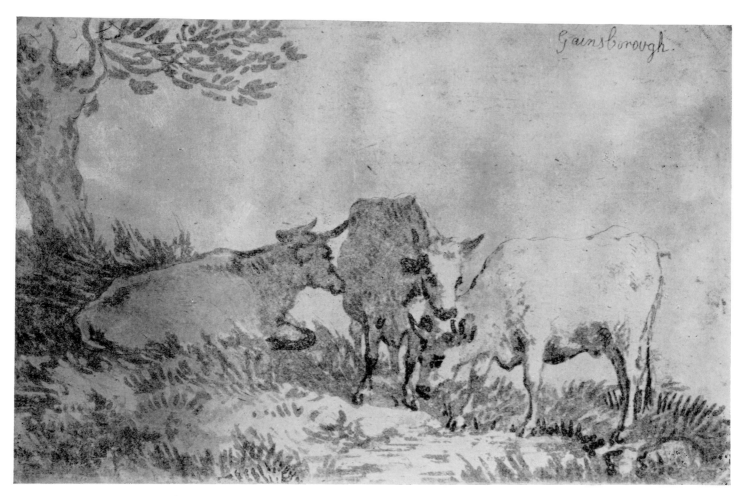

37 Aquatint with drypoint (No.3).

3 Three Cows on a Hillside
Early 1770's

Aquatint with drypoint. 5×8; 127×203.
Signed top right: *Gainsborough*.

Impressions printed in grey are in the British Museum (1872–6–8–283) (Pls **10** and **37**) and the Birmingham City Art Gallery.

Executed in aquatint, by the sugar-lift process, with some additional work and the signature in drypoint. The modelling is not particularly subtle, and the effect of sunlight and strong shadow achieved in the drawing (see below) is totally lost. A drawing in the British Museum (G–g–3–390) (Hayes 326) (Pl.**38**), which is in reverse from the print, is a preliminary study. This drawing was subsequently engraved by Rowlandson in his *Imitations of Modern Drawings* (No.15 in the series in the British Museum) (Pl.**40**). Gainsborough used the motif of three cows grouped together in a number of paintings and drawings dating from the early 1770's, and the technique for delineating the foliage and grass is also characteristic of this period: compare the *Peasants Going to Market* at Royal Holloway College (Waterhouse 911), which was paid for 6 July 1773 and dates from about 1768–71, or the drawing of cows being driven home presented to Viscount Bateman in September 1770, and now owned by Mrs J. Peyton-Jones (Hayes 312) (Pl.**39**).

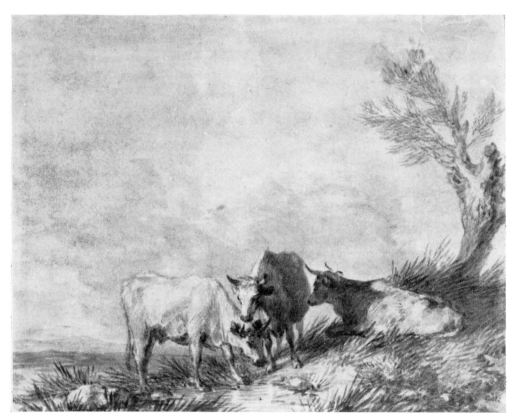

38 Watercolour. Study for No.3.

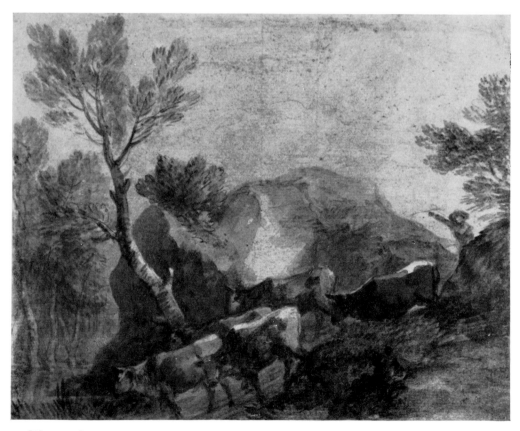

39 Watercolour.

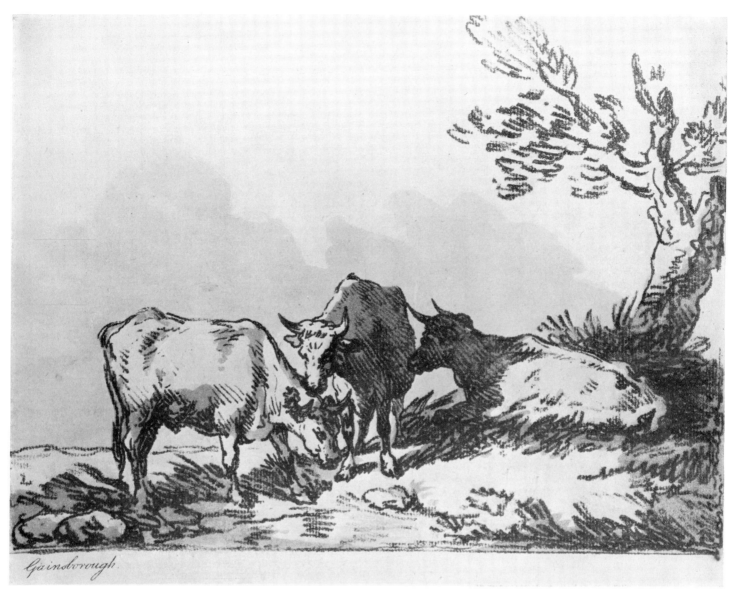

40 *Rowlandson.* Soft-ground etching with aquatint after Gainsborough, from *Imitations of Modern Drawings, c.*1788.

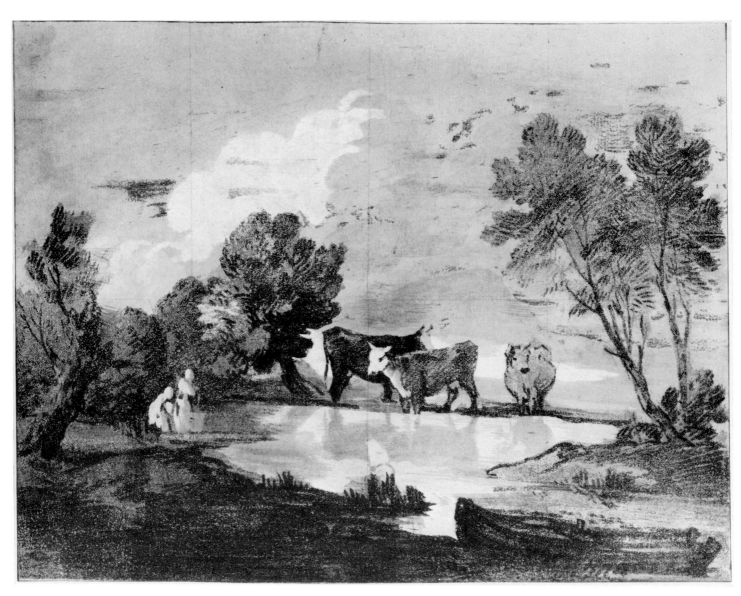

41 Soft-ground etching with aquatint (No.4).

4 Wooded Landscape with Figures, Boat and Cows beside a pool
Mid to later 1770's

Soft-ground etching with aquatint. $9\frac{3}{4} \times 12\frac{5}{8}$; 248×321.

A trimmed impression printed in grey is in the Ehemals Staatliche Museen, Berlin-Dahlem (185–1913) (Pl.**41**). A number of small hand-corrections (in the tree on the left and on the ground to its right, round the right-hand figure, to the right of the trunk of the tree in the middle, and on the trunks of the trees on the right) indicate that this is a preliminary state of this subject.

BIBLIOGRAPHY: Woodall No.9.

Executed in soft-ground etching, with considerable re-working to produce the darker passages and enrich the composition and the more delicate effects in a smooth light aquatint. There are a number of scratches, presumably on the plate, and it is partially squared. The method of handling the foliage and its loose relationship to the branches is similar to the drawing for *The Gypsy Encampment* (Tate Gallery 5803: Waterhouse 936) owned by Mr and Mrs Paul Mellon (Hayes 436) (Pl.**42**), which dates from the mid to later 1770's.

42 Drawing.

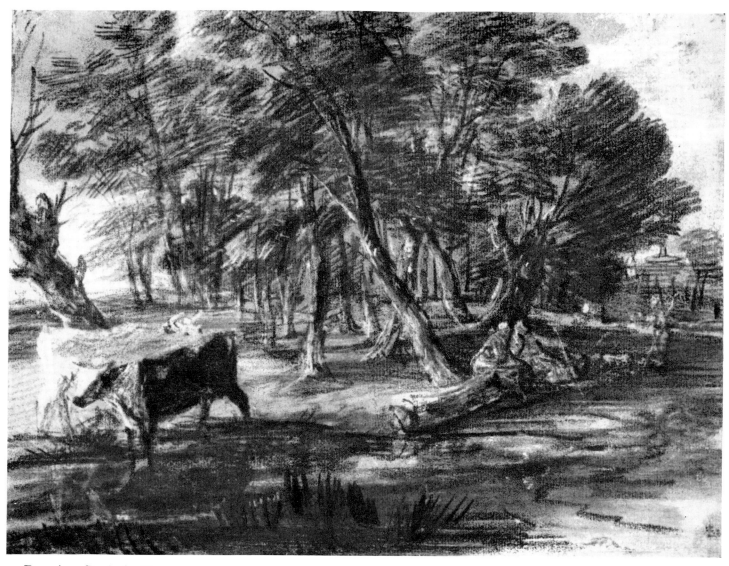

43 Drawing. Study for No.5.

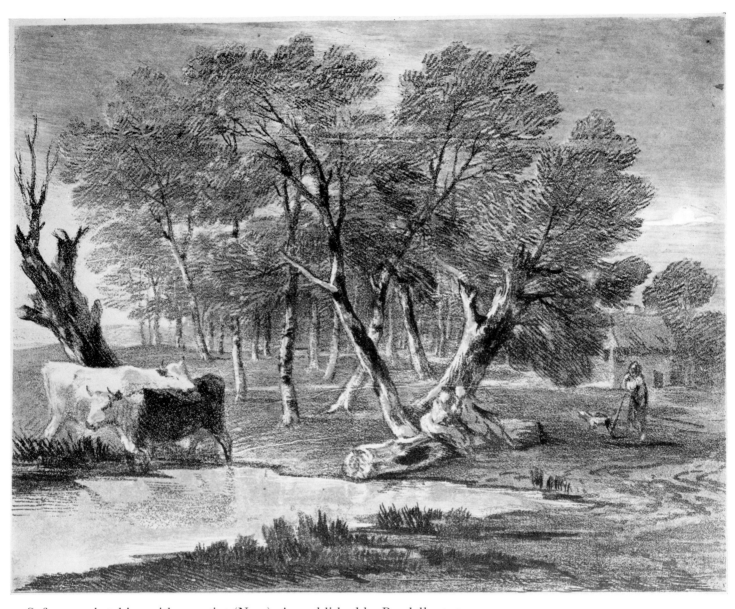

44 Soft-ground etching with aquatint (No.5). As published by Boydell, 1797.

5 Wooded Landscape with Cows beside a Pool, Figures and Cottage

Mid to later 1770's

Soft-ground etching with aquatint. $11\frac{1}{16} \times 13\frac{3}{4}$ ($10 \times 12\frac{3}{4}$); 281×349 (254×324). The copper plate is in the Tate Gallery.

Published by J. & J. Boydell, 1 August 1797 (No.4 in a series of 12).
Impressions numbered 4 top left outside the margin and printed in grey are in the Rhode Island School of Design and the Cleveland Museum of Art; impressions printed in brown are in the Victoria and Albert Museum (E.3234–1914) and the Henry E. Huntington Art Gallery. Trimmed and unnumbered impressions are in the Ehemals Staatliche Museen, Berlin-Dahlem (184–1913), the Metropolitan Museum of Art (37.43.10) (Pl.**44**) and Christchurch Mansion, Ipswich (all grey).

BIBLIOGRAPHY: Mrs Arthur Bell, *Thomas Gainsborough*, London, 1897, repr. facing p.12; Walter Shaw Sparrow, *A Book of British Etching*, London, 1926, repr. facing p.126; Woodall, p.95 and No.8.

Executed in soft-ground etching, with considerable re-working to reinforce the modelling, some additional work with the burin, and the more delicate effects in a smooth light aquatint; the whites are obtained by stopping-out. The long lateral marks which appear to be due to creases in the paper are the result of defects on the plate. Some work has been burnished out close to the moon. A black and white chalk drawing of the same size as the etching in the collection of John Tillotson (Hayes 437) (Pl.**43**), is a preparatory study for this print; there are slight differences in the foreground and the cottage is not yet included. The poses of the two cows are very similar to those in No.4, and the technique for handling the trees and foliage is even closer to the drawing for *The Gypsy Encampment* in the Mellon Collection (Hayes 436) (Pl.**42**). The drawing in the J. P. Heseltine sale, Sotheby's, 29 May 1935, lot 412 bt. Markey, described as 'Drawn on a fine impression of a soft-ground etching', is executed on an impression of No.5, strengthening the composition rather heavily in black and white chalks and altering it slightly in the right foreground. See pp.24–7 above for a discussion of the Boydell series.

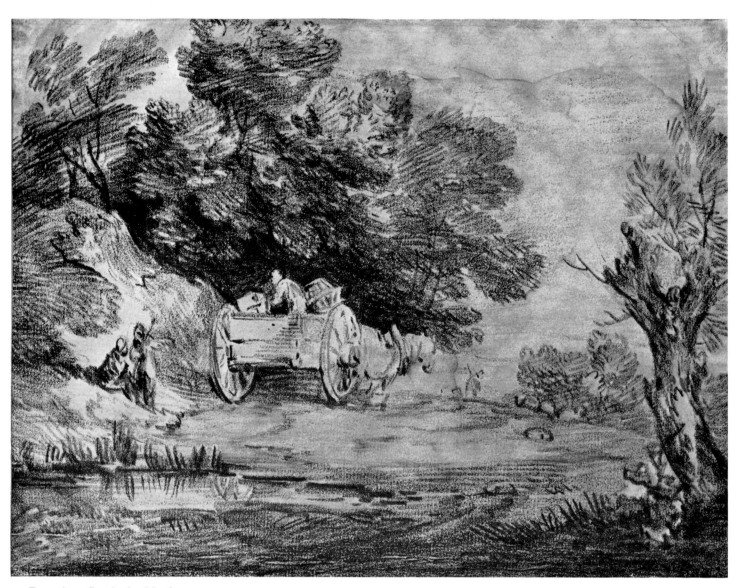

45 Drawing. Study for No.6.

6 Wooded Landscape with Country Cart and Figures

Mid to later 1770's

Soft-ground etching with aquatint. $11\frac{1}{16} \times 13\frac{3}{4}$ ($9\frac{7}{8} \times 12\frac{3}{4}$); 281×349 (251×324). The copper plate is in the Tate Gallery.

Published by J. & J. Boydell, 1 August 1797 (No.9 in a series of 12).
An impression numbered 9 top left outside the margin and printed in brown is in the British Museum (Anderdon's extra-illustrated copy of Edwards's *Anecdotes of Painters*, f.296) (Pl.**47**: detail Pl.**13**). Trimmed and unnumbered impressions are in the British Museum (52–7–5–227 and 228) and the Ehemals Staatliche Museen, Berlin-Dahlem (190–1913) (all grey), and in the British Museum (1866–12–8–354) (brown).

First state: before the re-working, the use of the punch and the addition of aquatint (Christchurch Mansion, Ipswich: 1917–12.5) (printed in grey) (Pl.**46**: detail Pl.**12**).

BIBLIOGRAPHY: Woodall, p.95 and No.11, repr. pl.119.

Executed in soft-ground etching, with considerable re-working to reinforce the modelling, a smooth light aquatint in the sky and elsewhere, and considerable use of a punch (less regular than the roulette) to enrich the texture. Some slight pentimenti are visible in the outlines of the trees, especially right, and some work has been burnished out in the sky. The lateral marks on the right which appear to be due to creases in the paper are the result of defects on the plate. A black chalk drawing in the Whitworth Art Gallery, University of Manchester (Hayes 407) (Pl.**45**), of the same size as the etching, corresponds closely in technique and effect and is a preliminary study for this print. The principal differences are in the disposition of the sheep and the inclusion of more branches and foliage in the tree on the right. The broad soft character of the chalkwork in this drawing is typical of the mid to later 1770's (e.g. the half-length portrait of a woman seated in the British Museum (1895–7–25–1) (Hayes 51) or the drawing in George Goyder's collection (Hayes 405)). In motif and composition No.6 is related to No.9. See pp.24–7 above for a discussion of the Boydell series.

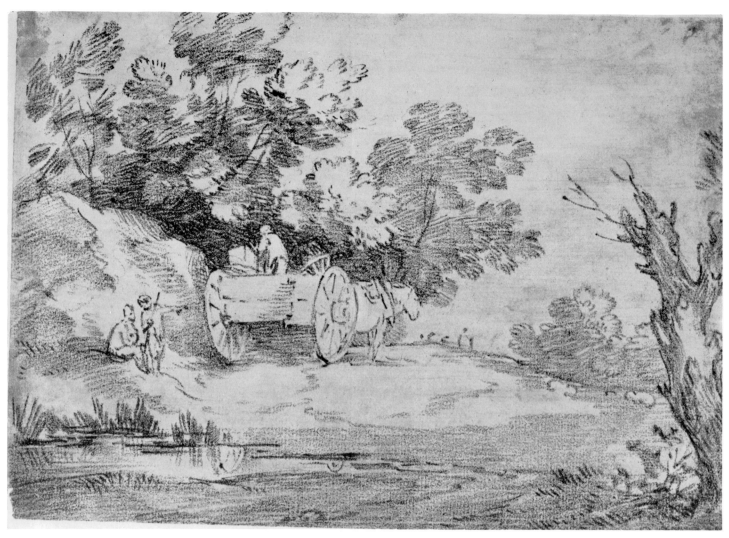

46 Soft-ground etching (No.6). First state.

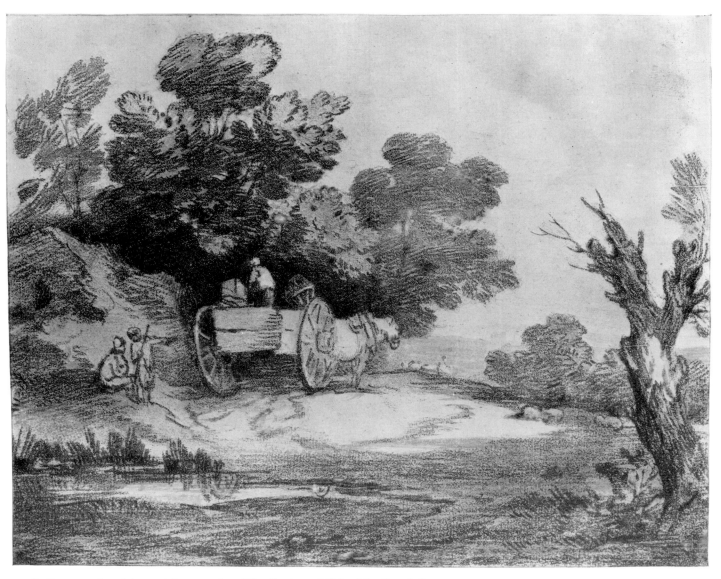

47 Soft-ground etching with aquatint (No.6). As published by Boydell, 1797.

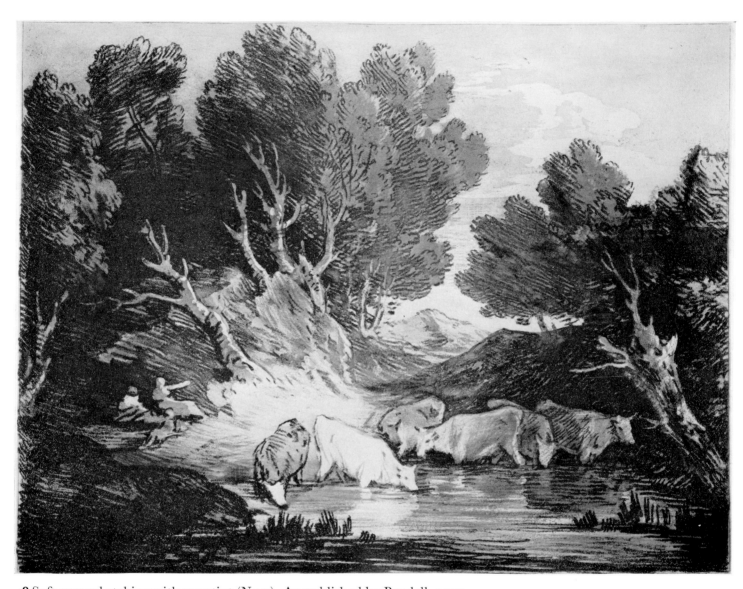

48 Soft-ground etching with aquatint (No.7). As published by Boydell, 1797.

7 Wooded Landscape with Figures and Cows at a Watering Place ('The Watering Place)
(The Watering Place)
About 1776–7

Soft-ground etching with aquatint. $11 \times 13\frac{3}{4}$ ($9\frac{11}{16} \times 12\frac{13}{16}$); 279×349 (246×325). The copper plate is in the Tate Gallery. There are a number of scratches.

Published by J. & J. Boydell, 1 August 1797 (No.6 in a series of 12).
Impressions numbered 6 top left outside the margin and printed in grey are in the British Museum (1866–12–8–356) (Pl.**48**: detail Pl.**14**) and the Metropolitan Museum of Art (49.50.106); an impression printed in brown is in the Victoria and Albert Museum (E.466–1949). Trimmed and unnumbered impressions are in the Tate Gallery (2210), Glasgow University and Christchurch Mansion, Ipswich (all grey).

First state: either an artist's or a Boydell proof, printed in grey, without letters, bearing the inscriptions beneath in brown ink: *Gainsbro' by himself, from Pewter Plates.* and: *Given by Mrs* (=Miss) *Gainsbro to Sr . . ./May. 1818* (Anon. sale, Sotheby's, 22 July 1971, Lot 223 bt. Colnaghi).

BIBLIOGRAPHY: George Williams Fulcher, *Life of Thomas Gainsborough, R.A.*, 2nd ed., London, 1856, p.28 Note; A. M. Hind, 'Notes on the History of Soft-Ground Etching and Aquatint', *The Print-Collector's Quarterly*, December 1921, p.382 and repr. facing; Walter Shaw Sparrow, *A Book of British Etching*, London, 1926, p.196; Woodall No.5.

Executed in soft-ground etching, with considerable re-working to produce the darker passages, a light aquatint in the sky and elsewhere, the adoption of the sugar-lift process for some of the middle tints in the foliage, and some use of the roulette; the whites are obtained by stopping-out. No.7 is almost identical in composition with the painting entitled *The Watering Place* exhibited at the Royal Academy 1777 and now in the National Gallery (Waterhouse No.937) (Pl.**50**), lacking only the herdsman on horseback and the two goats. Since the painting is rather more satisfactory in design from the inclusion of this additional staffage, it seems likely that the print preceded the completion of the painting (this applies also to Nos.10 and 11). The treatment of the foliage and the strong highlights in the rocks are closely related to the drawing of a landscape with horsemen and pack-horse owned by George D. Widener (Hayes 410) (Pl.**49**), which dates from the mid to later 1770's. See pp.**24–7** above for a discussion of the Boydell series.

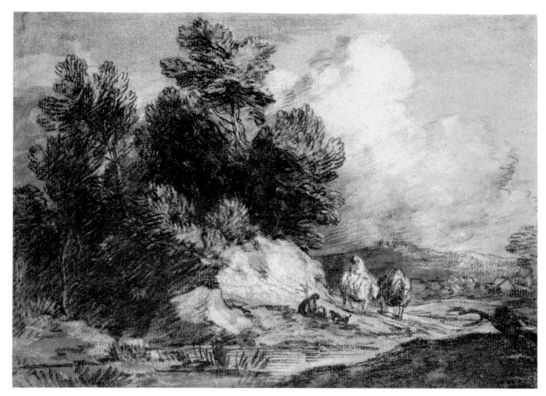

49 Drawing.

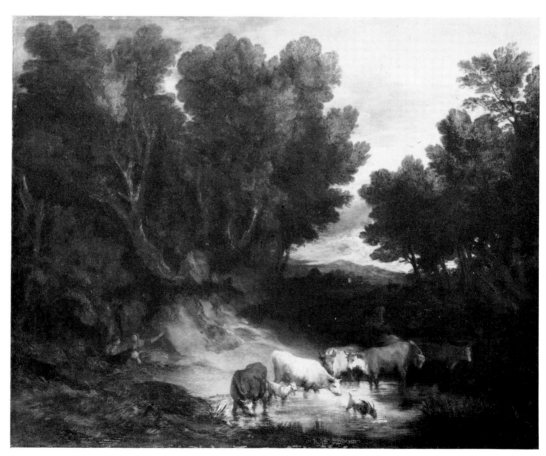

50 Painting. Exhibited R.A. 1777.

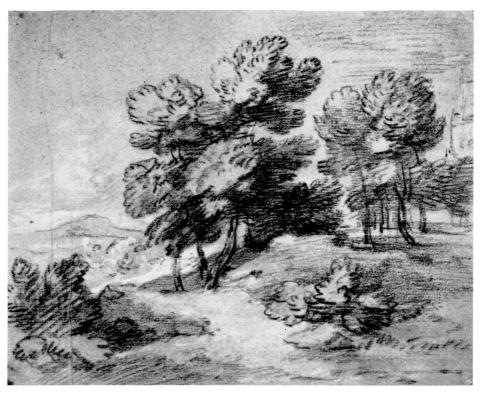

51 Drawing.

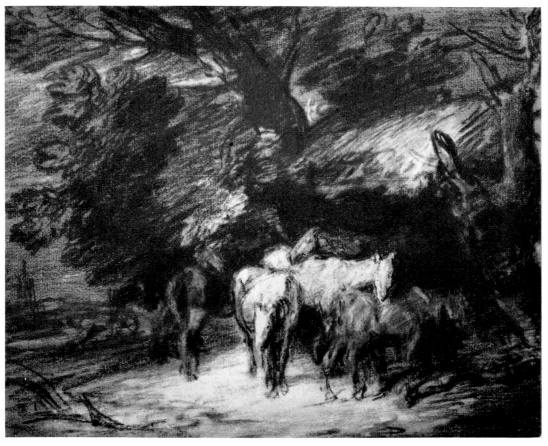

52 Drawing. Study for No.8.

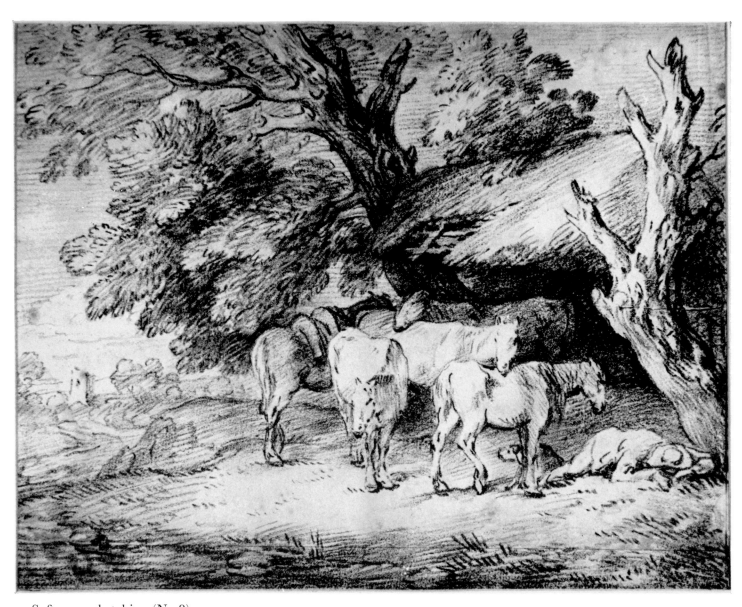

53 Soft-ground etching (No.8).

8 Wooded Landscape with Peasant and Horses outside a Shed
Mid to later 1770's

Soft-ground etching. $11\frac{1}{8} \times 13\frac{3}{4}$; 283×349.

An impression printed in grey is in the Witt Collection, Courtauld Institute of Art (2430) (Pl.**53**).

BIBLIOGRAPHY: Woodall, p.95 and No.16.

It is unlikely, in view of the extent to which the modelling in the horses has been taken, that the print in the Witt Collection is an early state before aquatint. This subject is therefore the first of Gainsborough's pure soft-ground etchings. A pastel on grey paper in the Tate Gallery (2227) (Hayes 403) (Pl.**52**) is a preliminary study for this print; the only differences lie in the substitution of a bank and winding track for the plough and ploughshare. The technique of this pastel is typical of the mid to later 1770's, and, like the drawing for No.6, it is similar to the drawing in George Goyder's collection (Hayes 405). The treatment of the foliage in the print is closely related to the drawing in the British Museum (1910–2–12–253) (Hayes 413) (Pl.**51**), which dates from the same period. The subject is closely related to No.22.

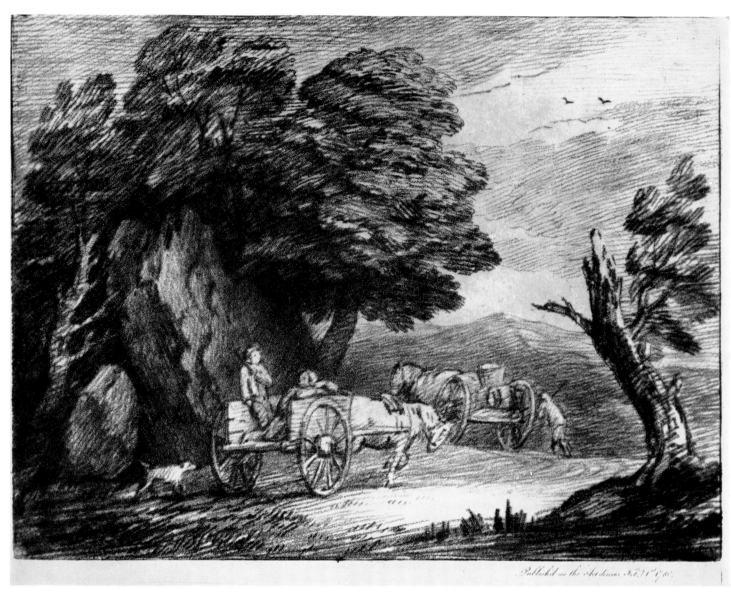

Published in the Act directs Feb 11th 1780.

54 Soft-ground etching (No.9). First state, 1780.

9 Wooded Landscape with Two Country Carts and Figures
1779–80

Soft-ground etching. 11 $\frac{11}{16}$ × 15$\frac{1}{2}$; 297 × 394.

Republished by J. & J. Boydell, 1 August 1797 (No.3 in a series of 12), with letters on a separate plate below.
Impressions numbered 3 top left and printed in grey are in the Metropolitan Museum of Art (42.27.3: hand-coloured and 49.95.62: partially trimmed) and the Tate Gallery (2718) (trimmed); impressions printed in brown are in the Rijksmuseum (60.133) and the Henry E. Huntington Art Gallery (Pl.**57**). Impressions with numbers erased printed in brown are in the Ehemals Staatliche Museen, Berlin-Dahlem (189–1913) and the Davison Art Center, Wesleyan University, Middletown, Conn. (trimmed).

First state: with the composition finished; trial printed text bottom right: *Publish'd as the Act directs, Feby 1st 1780,* (and a word erased) (Henry E. Huntington Art Gallery) (printed in grey) (Pl.**54**: detail Pl.**18**). An impression printed in grey in the Mellon Collection, which is trimmed to the subject, has an original eighteenth-century mount bearing the inscriptions: *Gainsborough fecit with his own hand on soft copper* (bottom left in brown ink) and: *The Drawings by Gainsborough are executed by his hand on soft copper ground – | Colnaghi* (on the verso, also in brown ink, but by a different hand, not identifiable as that of either Paul or Dominic Colnaghi). Another impression printed in grey in the British Museum (1866–12–8–355), also trimmed to the subject, bears the inscription: *Gainsborough fecit etch'd on a soft ground by him* on the back of the original mount in brown ink (the hand is not the same as in either of the inscriptions on the Mellon print). Both these impressions are identical in detail and quality with the Huntington proof, and were clearly pulled by the artist himself; they may or may not have possessed the same trial text.

BIBLIOGRAPHY: Walter Shaw Sparrow, *A Book of British Etching*, London, 1926, p.196 Note; Woodall No.13; John Hayes, 'Gainsborough's Later Landscapes,' *Apollo*, July 1964, p.21; *Gainsborough and the Gainsboroughesque*, Henry E. Huntington Library and Art Gallery, November 1967–February 1968, pp.10–11.

Executed in soft-ground etching. The design is similar to a wash drawing of the mid to later 1770's in the collection of Earl Spencer (Hayes 462) (Pl.**55**), which however includes only one cart and has other variations. The subject is also related to No.6. The treatment of the foliage is closely related to the drawing of cows and sheep by a cottage owned by Mrs N. Argenti (Hayes 424) (Pl.**56**), dating from the same period. See p.17 above for a discussion of the Huntington proof, and pp.24–7 for a discussion of the Boydell series.

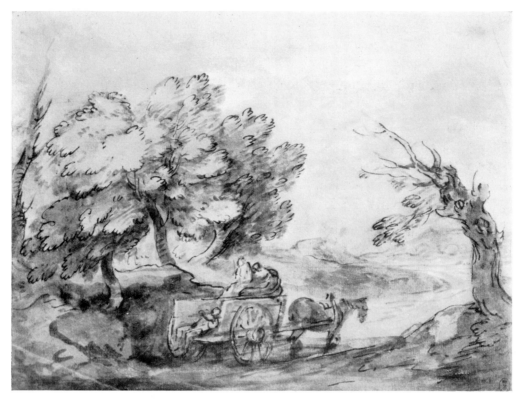

55 Drawing.

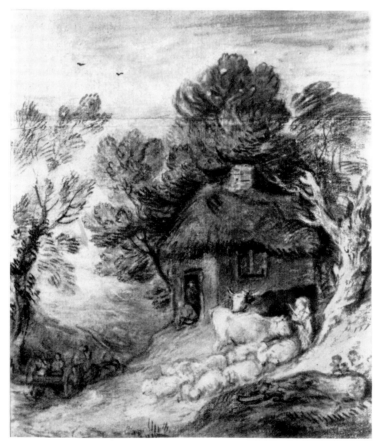

56 Drawing.

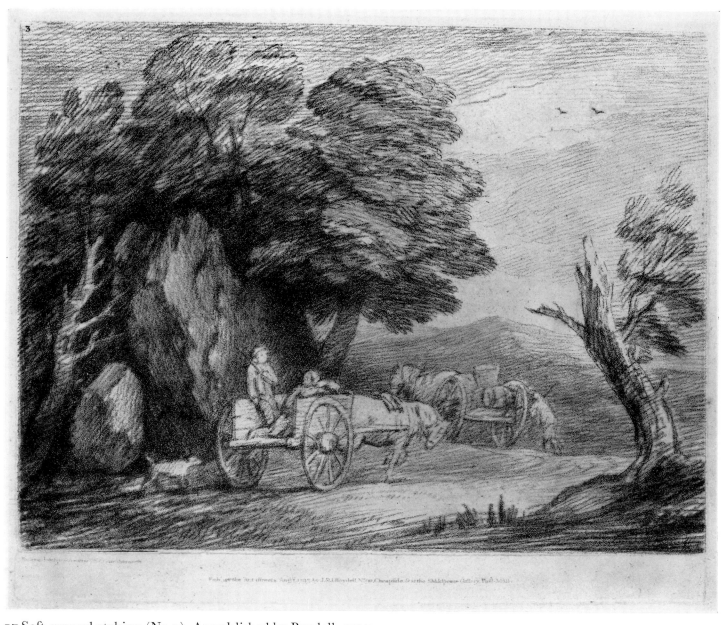

57 Soft-ground etching (No.9). As published by Boydell, 1797.

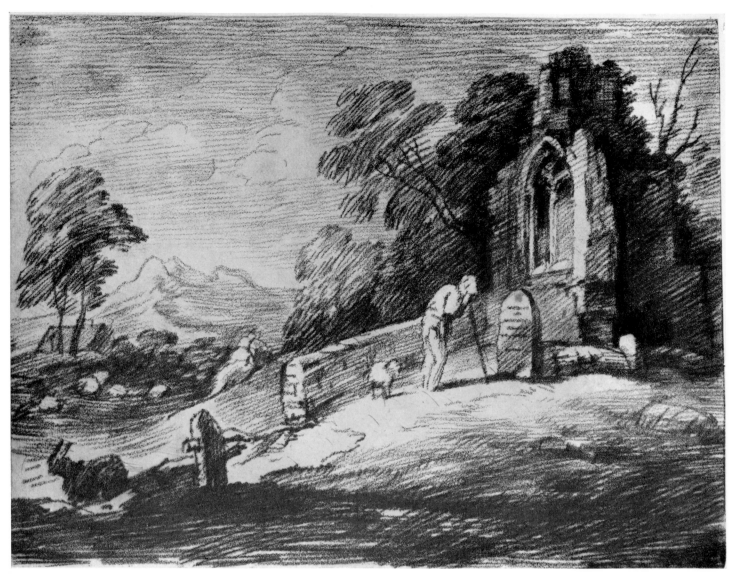

58 Soft-ground etching (No. 10). First state.

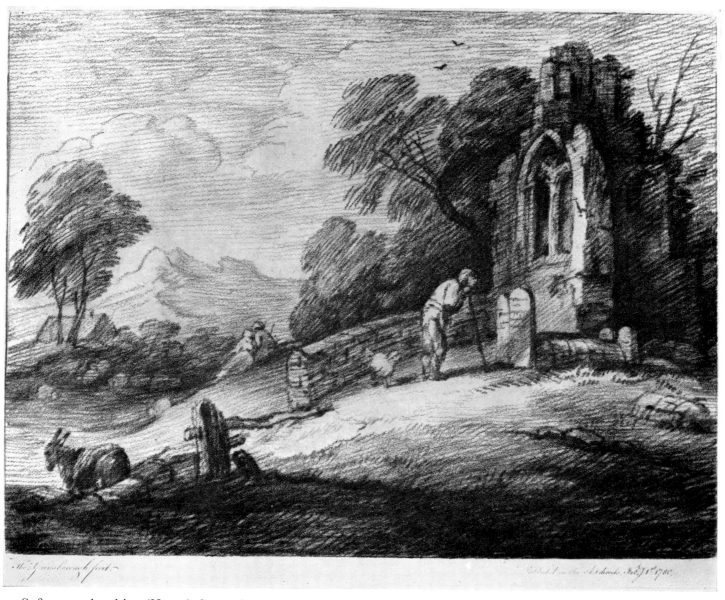

59 Soft-ground etching (No.10). Second state, 1780.

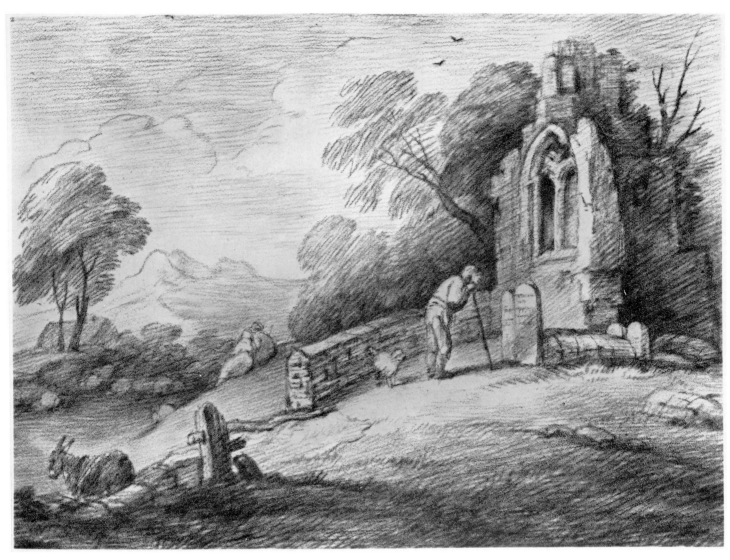

60 Soft-ground etching (No. 10). As published by Boydell, 1797.

10 Wooded Landscape with Peasant Reading Tombstone, Rustic Lovers and Ruined Church
1779–80

Soft-ground etching. $11\frac{11}{16} \times 15\frac{1}{2}$; 297×394.

Republished by J. & J. Boydell, 1 August 1797 (No.2 in a series of 12), with letters on a separate plate below.
Impressions numbered 2 top left and printed in grey are in the British Museum (47–7–13–48 (Pl.**60**) and 52–7–5–262: trimmed), the Tate Gallery (2717: trimmed), the Metropolitan Museum of Art (42.27.2) (hand-coloured), and the Mellon Collection (trimmed and printed on thin blue laid paper); an impression printed in brown (trimmed) is in the Ehemals Staatliche Museen, Berlin-Dahlem (196–1913).

First state: without the birds, the second headstone, the features of the peasant, and a good deal of modelling in the foreground; without letters (Ehemals Staatliche Museen, Berlin-Dahlem (195–1913) (printed in grey) (Pl.**58**: detail Pl.**16**).

Second state: with the composition finished and most of the scratches visible in the first state (presumably defects on the plate) burnished out; trial printed text bottom left: *Tho. Gainsborough fecit.* and bottom right: *Publish'd as the Act directs, Feb. 1. 1780,* (and a word erased) (Henry E. Huntington Art Gallery) (printed in grey) (Pl.**59**: detail Pl.**17**). An impression owned by the Hon. Christopher Lennox-Boyd, which is trimmed on the plate-mark, has (according to the entry in Christopher Mendez's Catalogue No.7, *English Prints*, October 1968 (10 repr.)) an original eighteenth-century mount bearing the inscriptions: *Gainsborough fecit on soft copper with his own hand* and: *The drawings by Gainsborough are executed by his hand on soft copper ground* (the latter signed Colnaghi). This is identical in detail and quality with the Huntington proof, and was clearly pulled by the artist himself; it may or may not have possessed the same trial text.

Third state: Boydell proof printed in grey, numbered 2 top left, but without letters, bearing the inscriptions beneath in brown ink: *Gainsbro by himself on Pewter.* and: *presented by M^{rs}* (=Miss) *Gainsbro t^o S^r JL* (Anon. sale, Sotheby's, 22 July 1971, Lot 221 bt. Colnaghi).

BIBLIOGRAPHY: Mrs Arthur Bell, *Thomas Gainsborough*, London, 1897, repr. facing p.14; Woodall, p.95 and No.3; John Hayes, 'Gainsborough's Later Landscapes', *Apollo*, July 1964, p.21; *Gainsborough and the Gainsboroughesque*, Henry E. Huntington Library and Art Gallery, November 1967–February 1968, pp.10–11, the second state repr. p.11.

Executed in soft-ground etching. Related in subject and composition, but not in detail, to the painting of *The Country Churchyard* exhibited at the Royal Academy

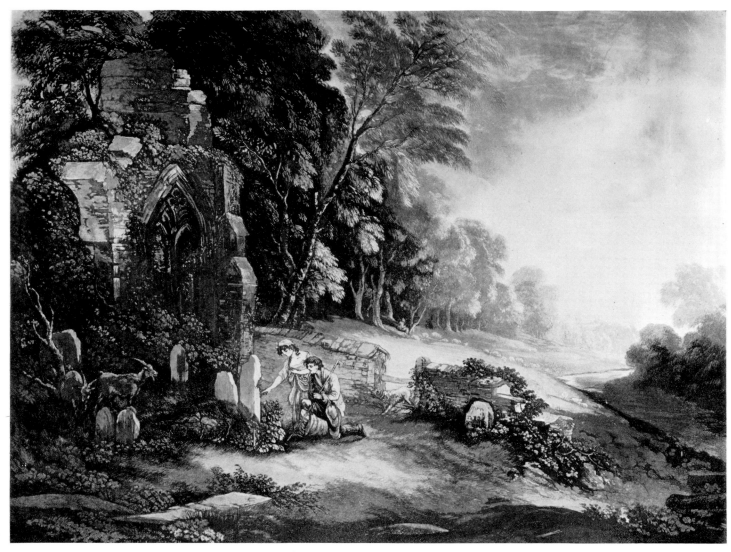

61 *Prestal*. Aquatint after Gainsborough, published 1790.

1780, of which only two fragments survive (one last recorded with Parsons 1911 (Waterhouse 942), and the other in the Countess of Sutherland's collection (Waterhouse 1000a)). The painting, of which we have a complete record in Prestal's aquatint of 1790 (Pl.**61**), is considerably more developed in composition, and was presumably executed subsequent to the completion of the print, though it was exhibited only some three months later. The theme of a churchyard with ruined church had been in Gainsborough's mind since the late 1750's, as a drawing of such a subject with a couple of donkeys beside two gravestones is in the Oppé Collection (1429) (Hayes 189) (Pl.**62**). See p.17 above for a discussion of the Huntington proof, and pp.24–7 for a discussion of the Boydell series.

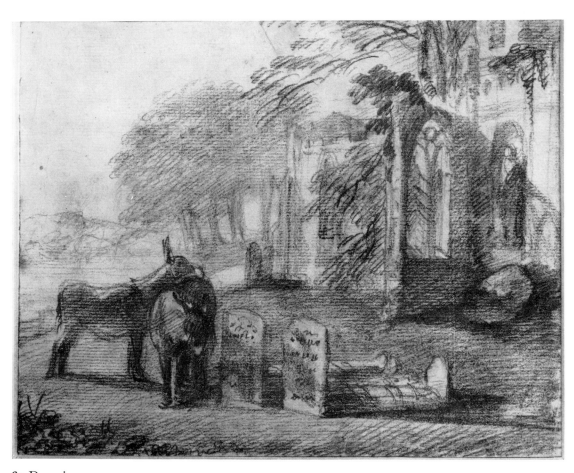

62 Drawing.

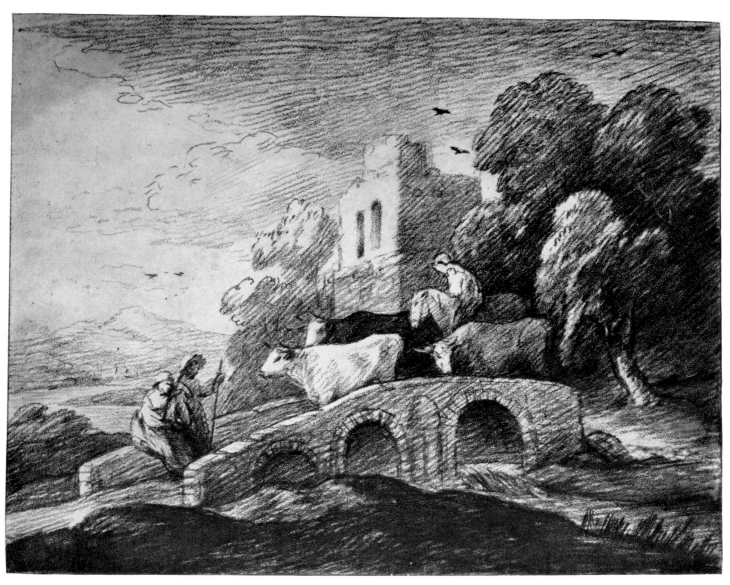

63 Soft-ground etching (No.11). First state.

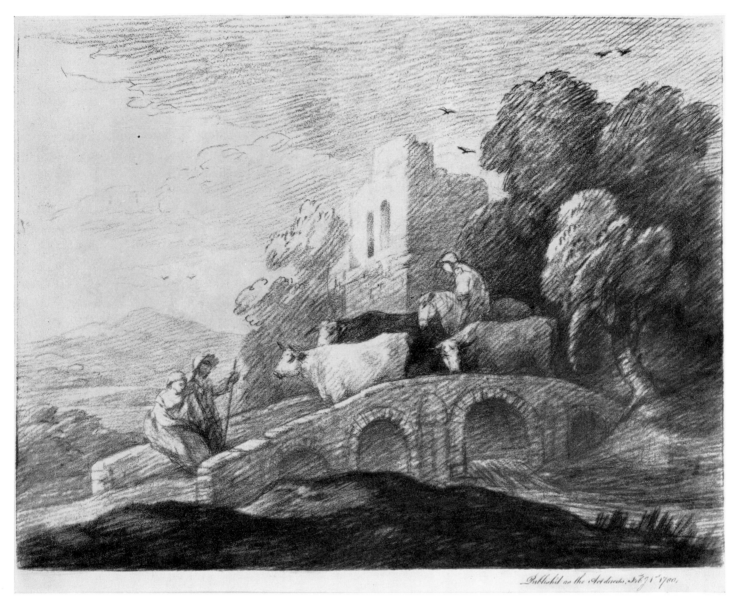

64 Soft-ground etching (No. 11). Second state, 1780.

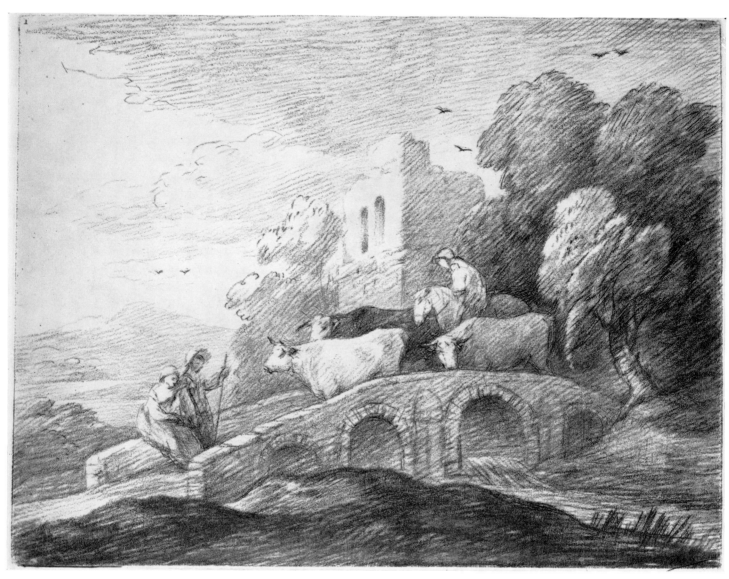

65 Soft-ground etching (No. 11). As published by Boydell, 1797.

11 Wooded Landscape with Herdsman Driving Cattle over a Bridge, Rustic Lovers and Ruined Castle

1779–80

Soft-ground etching. $11\frac{13}{16} \times 15\frac{1}{2}$; 300×394.

Republished by J. & J. Boydell, 1 August 1797 (No.1 in a series of 12), with letters on a separate plate below.

Impressions numbered 1 top left and printed in grey are in the British Museum (47–7–13–49), the Victoria and Albert Museum (E.603–1916) (hand-coloured), the Metropolitan Museum of Art (42.27.1) (hand-coloured), the Rhode Island School of Design, and the Mellon Collection (trimmed and printed on thin blue laid paper); an impression printed in brown is in the Davison Art Center, Wesleyan University, Middletown, Conn. (Pl.**65**).

First state: without the fourth arch in the bridge; without letters (Ehemals Staatliche Museen, Berlin-Dahlem (197–1913)) (printed in grey and heightened with white) (Pl.**63**).

Second state: with the composition finished; trial printed text bottom right: *Publish'd as the Act directs, Feb.ʸ 1ˢᵗ 1780,* (and a word erased) (Henry E. Huntington Art Gallery) (printed in grey) (Pls **15** and **64**). An impression printed in grey, trimmed within the platemark, is in the British Museum (52–7–5–229). This is identical in detail and quality with the Huntington proof, and was clearly pulled by the artist himself; it may or may not have possessed the same trial text.

BIBLIOGRAPHY: Max J. Friedländer, 'Gainsborough als Radierer', *Kunst und Künstler*, Vol.14, September 1915, the first state repr. p.18; Walter Shaw Sparrow, *A Book of British Etching*, London, 1926, p.126 and repr. facing p.128; Woodall, p.95 and No.1; John Hayes, 'Gainsborough's Later Landscapes,' *Apollo*, July 1964, p.21; *Gainsborough and the Gainsboroughesque*, Henry E. Huntington Library and Art Gallery, November 1967–February 1968, pp.10–11.

Executed in soft-ground etching, with a little additional work in hard-ground etching. A pentimento is visible right, where Gainsborough had second thoughts about the placing of the fourth arch. An oval black and white chalk and grey wash drawing in the Witt Collection, Courtauld Institute of Art (4181) (Hayes 498) (Pl.**66**), which is a study for the large oval landscape exhibited at the Royal Academy 1781 and now in the C. M. Michaelis Collection (Waterhouse 959) (Pl.**67**), is closely related in composition to the print. The chief differences are the inclusion of a flock of sheep, a dog accompanying the herdsman, and a tree trunk bottom right, and the substitution of two for three cows. The dates of 1780 for the print and 1781 for the exhibited painting suggest that the print was executed before both drawing and painting. This is supported by the development which is discernible in the latter towards a more rhythmical composition. See p.17 above for a discussion of the Huntington proof, and pp.24–7 for a discussion of the Boydell series.

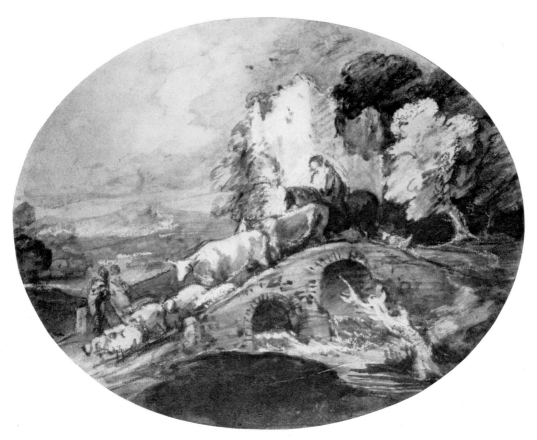

66 Drawing.

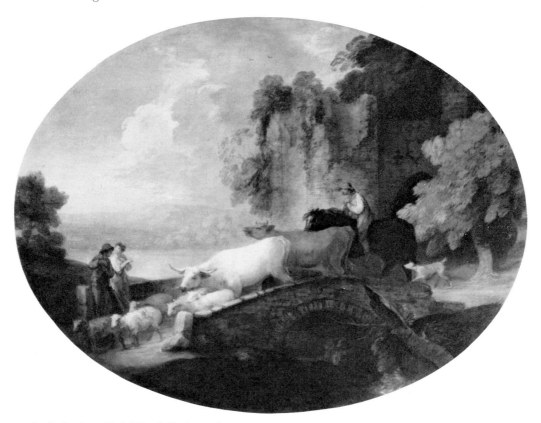

67 Painting. Exhibited R.A. 1781.

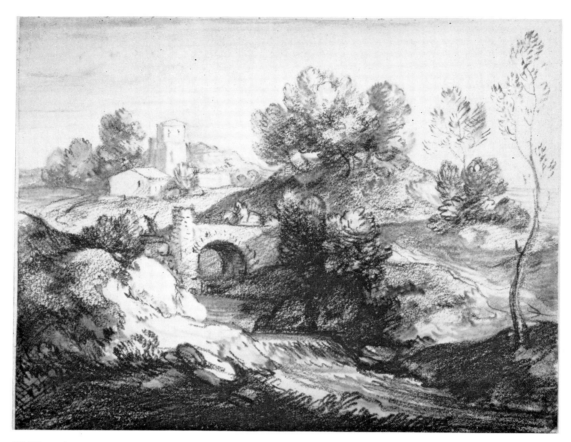

68 Drawing.

69 Drawing.

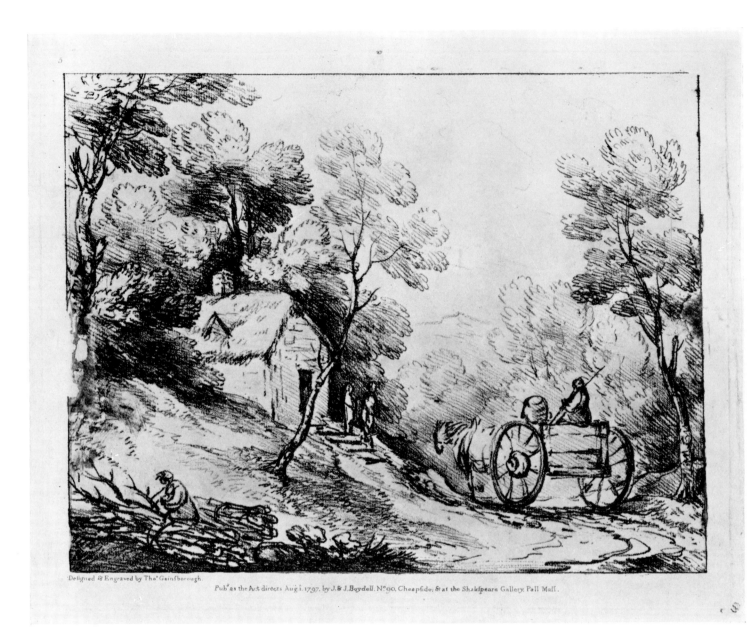

70 Soft-ground etching (No.12). As published by Boydell, 1797.

12 Wooded Landscape with Country Cart, Cottage and Figures
Mid-1780's

Soft-ground etching. $11\frac{1}{8} \times 13\frac{13}{16}$ ($9\frac{7}{8} \times 12\frac{11}{16}$); 283×351 (251×322). The copper plate (made by Guerre) is in the Tate Gallery. There are damages, caused probably by a clamp, on the left and right edges.

Published by J. & J. Boydell, 1 August 1797 (No.5 in a series of 12).
Impressions numbered 5 top left outside the margin and printed in grey are in the Birmingham City Art Gallery and the Fogg Art Museum (R15, 204); an impression printed in brown is in the Henry E. Huntington Art Gallery (Pl.**70**). Trimmed and unnumbered impressions are in the Tate Gallery (2721) (grey) and the Henry E. Huntington Art Gallery (brown).

First state: without number and letters (Metropolitan Museum of Art: 49.95.61) (printed in grey).

BIBLIOGRAPHY: Woodall No.14; F. L. Wilder, *How to Identify Old Prints*, London, 1969, repr. pl.66.

Executed in soft-ground etching. It seems possible, in view of the absence of modelling in the sky (the clouds are barely outlined) that Gainsborough intended to add aquatint. He may have abandoned the subject on account of the damage to the plate visible on the left. The loose feathery handling of the foliage is characteristic of Gainsborough's drawings in black chalk and stump of the mid-1780's, such as the landscape with horseman crossing a bridge in an English private collection (Hayes 629) (Pl.**68**). The motif of bundling up faggots is also typical of this period. This print was used in reverse, with minor differences, by Gainsborough Dupont for the composition of his painting now in the Birmingham City Art Gallery (Waterhouse 994 as Gainsborough). See pp.24–7 above for a discussion of the Boydell series.

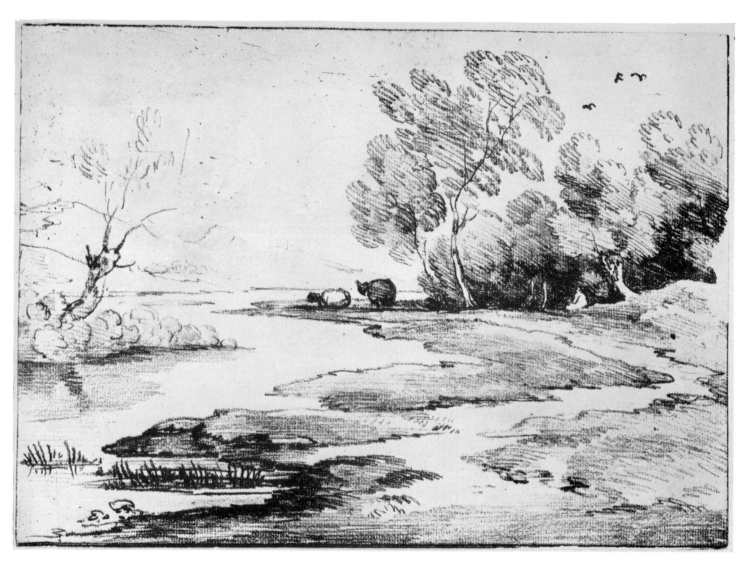

71 Soft-ground etching with aquatint (No.13).

13 Wooded River Landscape with Shepherd and Sheep
Mid-1780's

Soft-ground etching with aquatint. $11\frac{7}{16} \times 15$ ($9\frac{13}{16} \times 13\frac{3}{8}$); 291×381 (249×340). The copper plate (made by Jones & Pontifex, coppersmiths, 47 Shoe Lane) is in the Tate Gallery. Some damage has been caused on the right, probably by a clamp, and there are a number of small scratches.

Trimmed impressions printed in grey are in the British Museum (52–7–5–270), the Tate Gallery (2720) (Pl.**71**) and the Ehemals Staatliche Museen, Berlin-Dahlem (186–1913).

BIBLIOGRAPHY: Max J. Friedländer, 'Gainsborough als Radierer', *Kunst und Künstler*, Vol. 14, September 1915, repr. p.19; Woodall No.10.

Executed in soft-ground etching, with a smooth light aquatint in the sky and elsewhere. The motif of the river winding through the composition, the treatment of the foliage and sheep and the rough highlights in the clouds, are typical of Gainsborough's drawings of the mid-1780's such as the upland scene in the Tate Gallery (2223) (Hayes 776) (Pl.**69**).

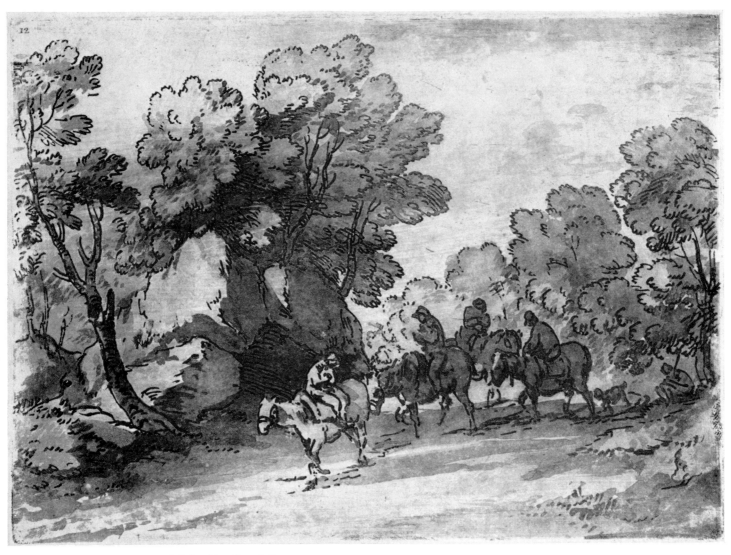

72 Aquatint (No.14). As published by Boydell, 1797.

14 Wooded Landscape with Riders
Mid-1780's

Aquatint. $7\frac{1}{4} \times 9\frac{11}{16}$; 184×246. The copper plate is in the Tate Gallery. There are a number of small scratches, and an area of slight damage top left.

Published by J. & J. Boydell, 1 August 1797 (No.12 in a series of 12), with letters on a separate plate below.
A partially-trimmed impression numbered 12 top left and printed in grey is in the Metropolitan Museum of Art (49.95.60) (Pl.**72**); impressions printed in brown are in the British Museum (52–7–5–243) (trimmed), the Henry E. Huntington Art Gallery and the Rijksmuseum (60.135).

First state: Boydell proof printed in grey, without number or letters, bearing the inscriptions beneath in brown ink: *Gainsbro' by himself* and: *presented by Mrs* ($=$ Miss) *Gainsbr* . . . (Anon. sale, Sotheby's, 22 July 1971, Lot 225 bt. Sinclair).

BIBLIOGRAPHY: Walter Shaw Sparrow, *A Book of British Etching*, London, 1926, p.125; Woodall No.6, repr. pl.118.

Executed in aquatint by the sugar-lift process, partially smooth, partially medium-grained in some of the lighter passages. The broken but fairly tight outlining of the foliage harks back to certain of Gainsborough's drawings of the later 1760's, e.g. those in the Louvre (Hayes 289) and the Mellon Collection (Hayes 303) (Pl.**74**), though the print clearly cannot date from this period, since it would then antedate No.3, Gainsborough's most immature work in aquatint. The composition is a variant of an oil sketch in the Witt Collection, Courtauld Institute of Art (1681) (Hayes 724) (Pl.**73**), which dates from the mid-1780's. This is the type of print upon which Rowlandson modelled his style in his *Imitations* (Pl.**75**). See pp.24–7 above for a discussion of the Boydell series.

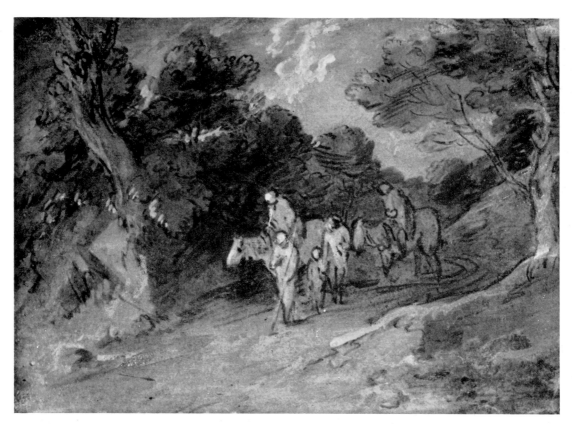

73 Drawing.

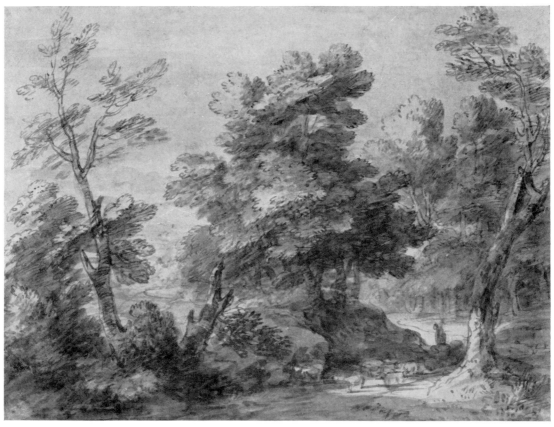

74 Drawing.

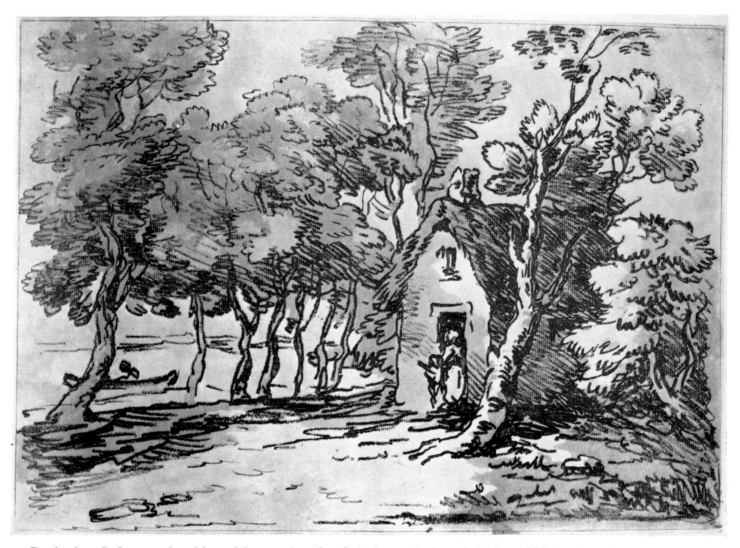

75 *Rowlandson*. Soft-ground etching with aquatint after Gainsborough, from *Imitations of Modern Drawings, c.*1788.

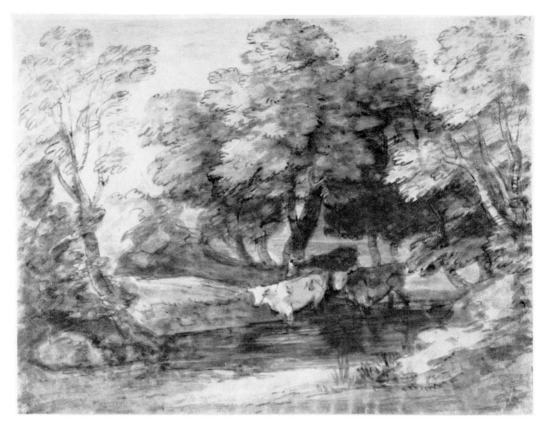

76 Drawing. Study for No.15.

77 Drawing.

15 Wooded Landscape with Three Cows at a Pool
Mid-1780's

Aquatint. $11\frac{1}{8} \times 13\frac{13}{16}$; 283×351. The copper plate is in the Tate Gallery. There are a number of scratches and a considerable blemish top left, perhaps caused by previous work on the plate.

A trimmed impression printed in grey is in the Tate Gallery (2722) (Pl.**78**).

First state: without most of the hatching, and before the foreground was diminished to form a margin (Ehemals Staatliche Museen, Berlin-Dahlem (188–1913) (printed in grey: a grey wash added after) (Pl.**79**).

Executed in aquatint by the sugar-lift process. In the first state, Gainsborough has simply outlined his composition on the plate, using grey wash to indicate the formal structure he was to follow. A grey wash drawing in the Pierpont Morgan Library (III,63a) (Hayes 454) (Pl.**76**) of the same size as the aquatint, is a preliminary study for this print, though probably dating from some years earlier. The treatment of the tree trunks and the loose scallops outlining the foliage in No.15 are closely related to the woodland drawing in the Henry E. Huntington Art Gallery (Hayes 530) (Pl.**77**), which dates from the early 1780's.

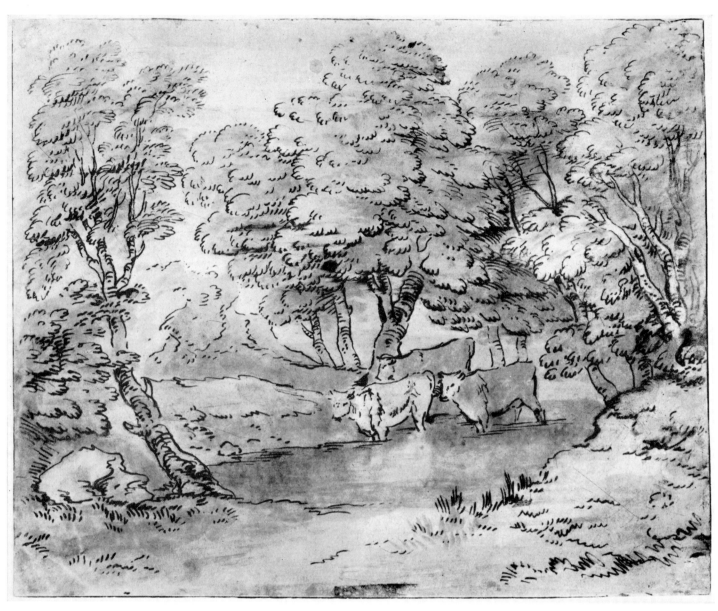

78 Aquatint, with grey wash added (No.15). First state.

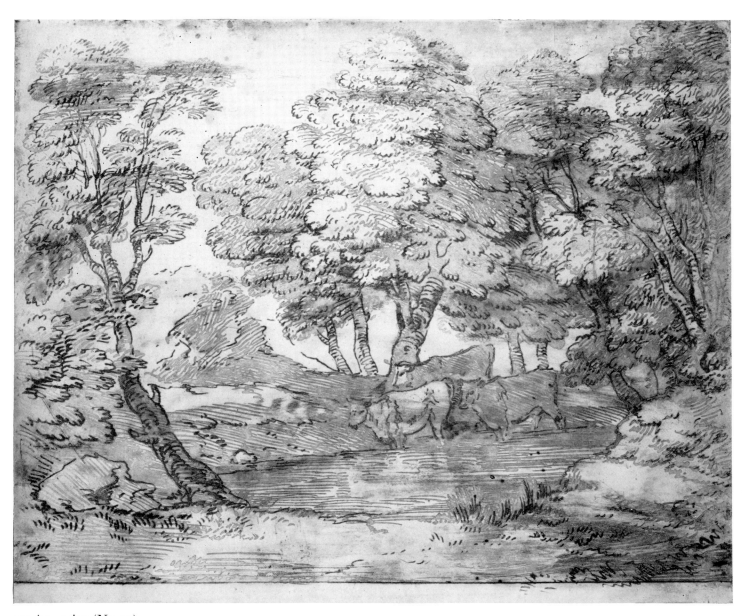

79 Aquatint (No.15).

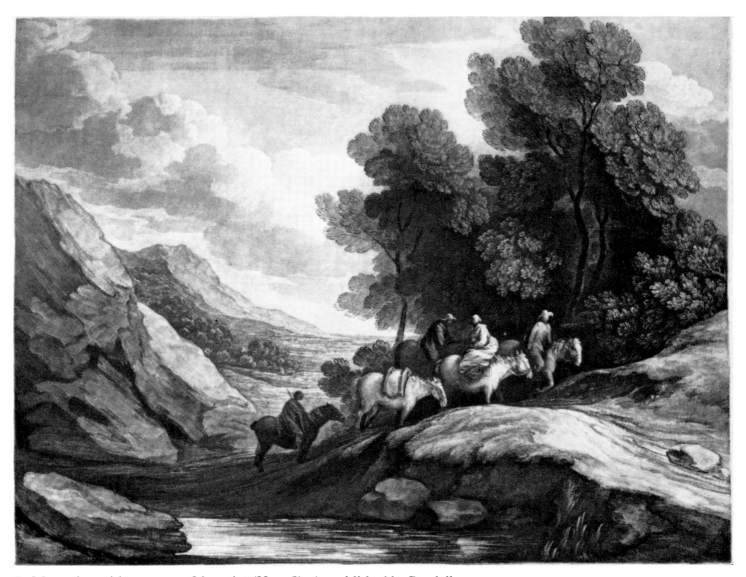

80 Mezzotint, with some use of drypoint (No. 16). As published by Boydell, 1797.

16 Wooded Upland Landscape with Riders and Packhorse
About 1783

Mezzotint, with some use of drypoint. 10 $\frac{15}{16}$ × 14 (9 $\frac{5}{16}$ × 12 $\frac{7}{16}$); 278×356 (237× 316). The copper plate (made by Jones & Pontifex, coppersmiths, 47 Shoe Lane) is in the Tate Gallery. It is unique among the known Gainsborough plates in being bevelled, though on the reverse side.

Published by J. & J. Boydell, 1 August 1797 (No.8 in a series of 12).
Impressions numbered 8 top left outside the margin and printed in grey are in the Rijksmuseum (60.136) (Pl.**80**) and the Henry E. Huntington Art Gallery.

BIBLIOGRAPHY: Woodall No.15.

Executed in mezzotint, with the use of drypoint in places to give crispness to some of the foliage and branches. The trees, rocks, treatment of the distance, and way in which all the forms are enveloped in a sweeping lateral rhythm are typical of Gainsborough's mountain landscapes of the mid-1780's, such as the painting now in an American private collection (Waterhouse 992) (Pl.**82**), executed in the autumn of 1783. The type of clouds echoing the silhouette of the landscape are closely paralleled in the drawing with herdsman and cows in Berlin (6851) (Hayes 687). The theme is related to No.14, and the tight scallops outlining the foliage are similar to those in Nos. 14 and 15. See pp.24–7 above for a discussion of the Boydell series.

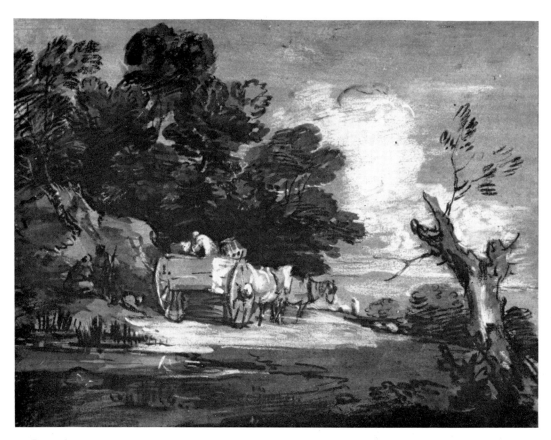

81 Drawing.

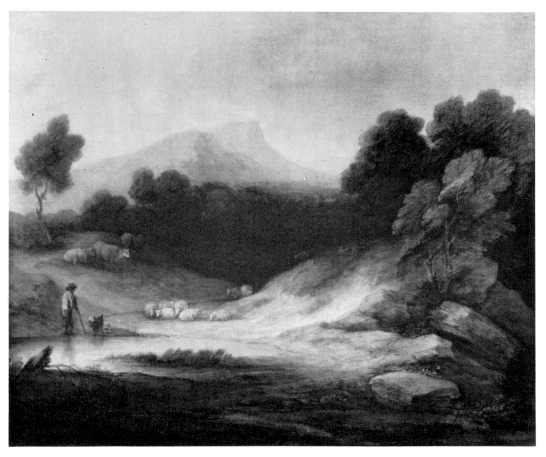

82 Painting executed 1783.

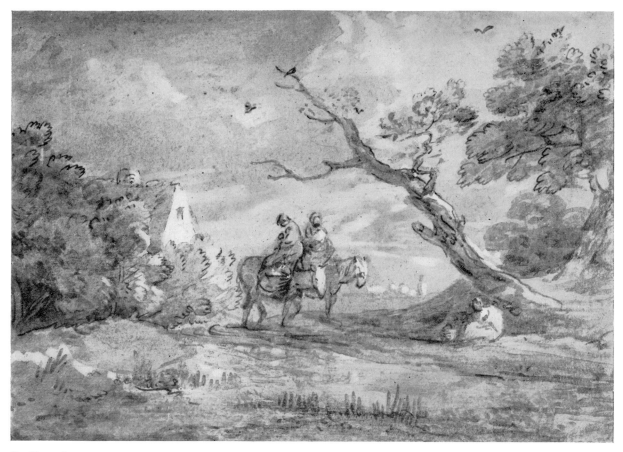

83 Drawing.

84 Drawing.

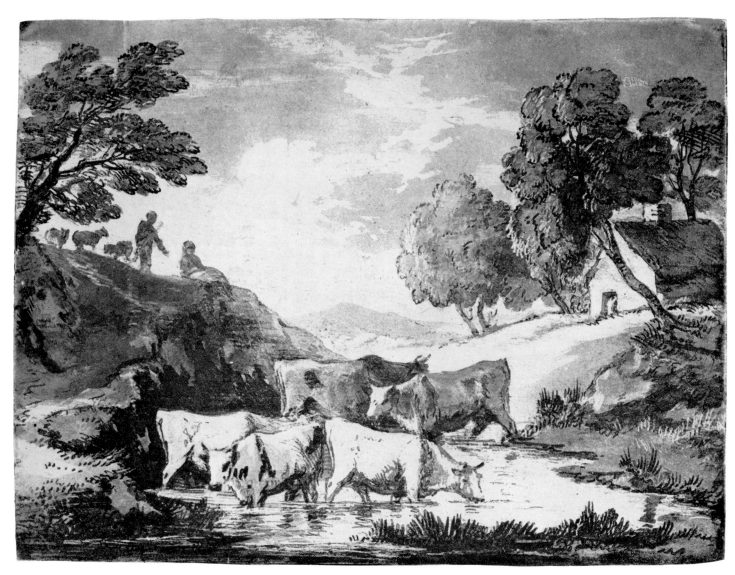

85 Aquatint (No.17).

17 Wooded Landscape with Cows at a Watering Place, Figures and Cottage
Mid-1780's

Aquatint. Plate size unknown. $7\frac{1}{8} \times 9\frac{7}{16}$; 181 × 240.

The only impression known, printed in brown and trimmed, is in the Minneapolis Institute of Arts (3564) (Pl.**85**). This is inscribed in ink on the verso bottom left: *1833. WE 20 Dr Munro's sale, by Gainsborough*. An inscription in ink presumably removed from the original mount reads (apparently in Gainsborough's hand): *a Print by T :G :* (and added by Esdaile): *& only one other, the plate being lost. In imitation of a Drawing*.

Executed in aquatint mainly by the sugar-lift process, with traces of the roulette in the foregound; the whites in the sky are obtained by stopping-out. There are one or two blemishes, presumably defects on the plate. Some measure of the advance which Gainsborough had made in the mastery of the medium in the course of a decade may be obtained by comparing this print with No.3. The style is closely related to Gainsborough's oil sketches of the early and mid-1780's, such as the study in the British Museum (G–g–3–392) (Hayes 511) (Pl.**83**), where the broken modelling of the clouds is comparable and a cottage among trees is included.

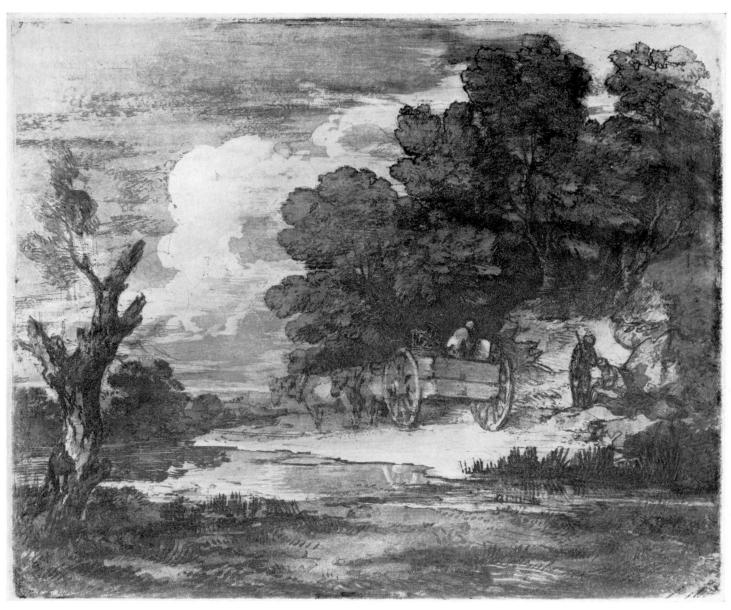

86 Aquatint (No.18). As published by Boydell, 1797.

18 Wooded Landscape with Country Cart and Figures
Mid to later 1780's

Aquatint. $11\frac{1}{8} \times 13\frac{3}{4}$; 283×349. The copper plate is in the Tate Gallery. There are a number of scratches. Some of the marks on the left seem to be caused by previous work on the plate.

Published by J. & J. Boydell, 1 August 1797 (No.7 in a series of 12), with letters on a separate plate below.
Impressions numbered 7 top left and printed in grey are in the Victoria and Albert Museum (E.465–1949), the Ehemals Staatliche Museen, Berlin-Dahlem (192–1913, and 191–1913: trimmed) and the Henry E. Huntington Art Gallery (Pl.**86**: detail Pl.**21**); an impression printed in brown is in the Rijksmuseum (60.134).

BIBLIOGRAPHY: Woodall No.12; Carl Zigrosser, *The Book of Fine Prints*, 3rd ed., revised, London, 1956, repr. pl. 299b.

Executed in aquatint by the sugar-lift process, with some work in a coarser grain to enrich the modelling; the whites in the sky are obtained by stopping-out. A black and white chalk and grey wash drawing of the same size as the etching, in the collection of Mrs W. W. Spooner (Hayes 754) (Pl.**81**), is a preparatory study for this print; the drawing is in reverse, but the only other differences lie in the inclusion of a dog with the figures on the left, and a shepherd and sheep in the middle distance centre. The loose handling of the foliage in this drawing is typical of a number of Gainsborough's late drawings, such as that in the Witt Collection, Courtauld Institute of Art (2428) (Hayes 760). The subject is in reverse from No. 6, but otherwise differs very little: there are two horses, and the pool stretches across the whole composition. See pp.24–7 above for a discussion of the Boydell series.

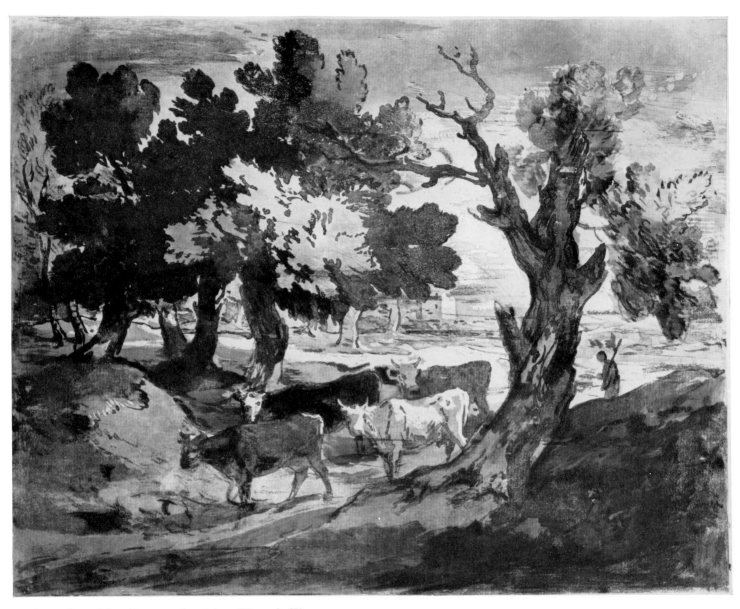

87 Aquatint with soft-ground etching (No.19). First state.

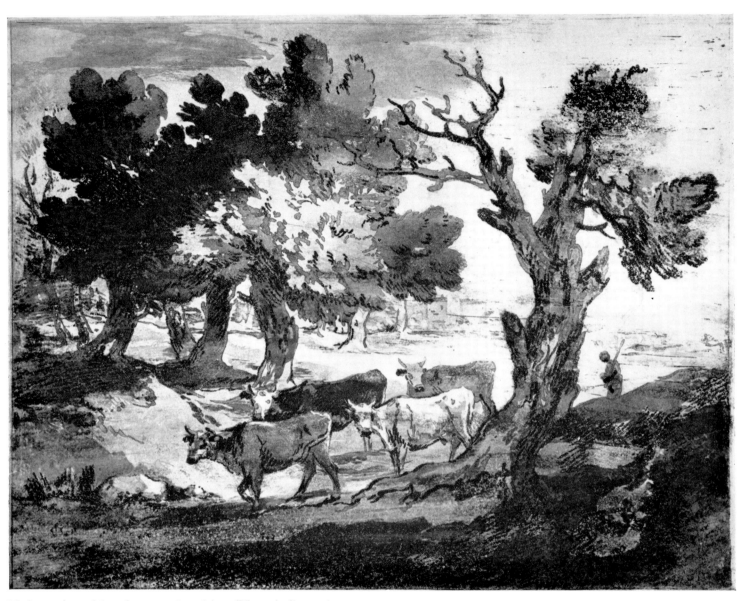

88 Aquatint with soft-ground etching (No.19). Second state.

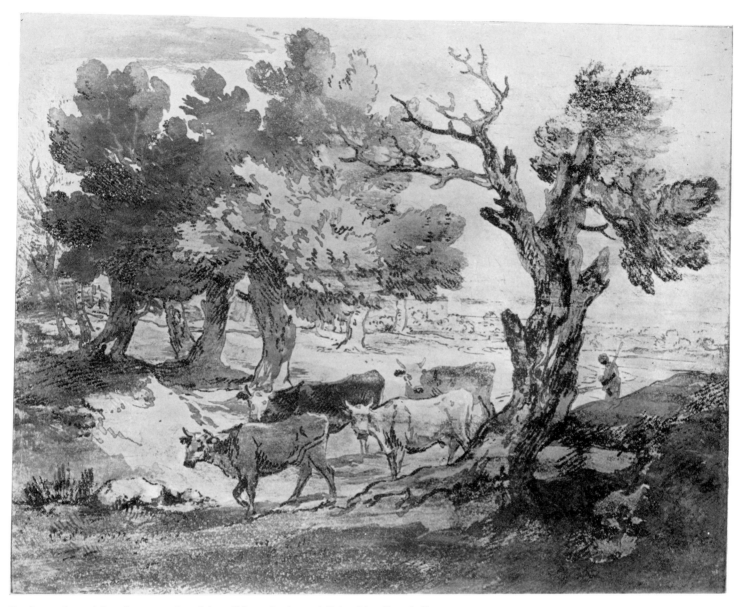

89 Aquatint with soft-ground etching (No.19). As published by Boydell, 1797.

19 Wooded Landscape with Herdsman and Cows

Mid to later 1780's

Aquatint with soft-ground etching. $11\frac{1}{16} \times 13\frac{3}{4}$ ($10\frac{1}{8} \times 12\frac{11}{16}$); 281×349 (257×322). The copper plate is in the Tate Gallery. There are a number of scratches.

Published by J. & J. Boydell, 1 August 1797 (No.10 in a series of 12).
Impressions numbered 10 top left outside the margin and printed in grey are in the British Museum (51–2–8–265: trimmed) (Pl.**89**), the Metropolitan Museum of Art (49.50.105) and the Mellon Collection; an impression printed in brown is in the Henry E. Huntington Art Gallery. A trimmed and unnumbered impression printed in grey is in the Ehemals Staatliche Museen, Berlin-Dahlem (194–1913) (heightened with white).

First state: before the addition of soft-ground; without the hatching, the distance centre and right, and a number of other details, e.g. the boulder and tufts of grass in the foreground left (Ehemals Staatliche Museen, Berlin-Dahlem (193–1913)) (printed in grey) (Pl.**87**: detail Pl.**19**). This impression has been corrected by the artist in grey wash in a number of places: in parts of the tree on the right, in all the cows and on the ground beneath them.

Second state: without the bushy trees in the distance centre and right, some of the strokes in the winding track, and some of the modelling in the tree trunks in the middle distance centre; inscribed beneath in brown ink: *Gainsbro by himself* and: *presented to S^r JL by M^rs* (= Miss) *Gainsbro* (Anon. sale, Sotheby's, 22 July 1971, Lot 222 bt. Mendez) (printed in grey) (Pl.**88**).

BIBLIOGRAPHY: Max J. Friedländer, 'Gainsborough als Radierer,' *Kunst und Künstler*, Vol.14, September 1915, the first state repr. p.17; E. S. Lumsden, *The Art of Etching*, London, 1925, repr. pl.48A; Walter Shaw Sparrow, *A Book of British Etching*, London, 1926, pp.124–5; Jan Poortenaar, *Etskunst Techniek en Geschiedenis*, Amsterdam, 1930, pp.111 and 159 and repr. pl.25; Woodall No.4.

Executed in aquatint by the sugar-lift process, with considerable use of soft-ground etching to add texture to the modelling. The loose treatment of the foliage and the brilliant effects of light can be paralleled in a number of Gainsborough's late sketches, such as the woodland scene with cottage owned by Richard S. Davis (Hayes 802) (Pl.**84**). See pp.24–7 for a discussion of the Boydell series.

90 Aquatint (No.20). As published by Boydell, 1797.

20 Wooded Landscape with Herdsman and Cows

Mid to later 1780's

Aquatint. $11\frac{1}{16} \times 13\frac{3}{4}$; 281×349. The copper plate is in the Tate Gallery. There are a few scratches.

Published by J. & J. Boydell, 1 August 1797 (No.11 in a series of 12), with letters on a separate plate below.

Impressions numbered 11 top left and printed in grey are in the British Museum (1930–8–21–7 and 47–7–13–50) and the Tate Gallery (2722a) (trimmed); impressions printed in brown are in the Henry E. Huntington Art Gallery (Pl.**90**: detail Pl.**20**), the Metropolitan Museum of Art (49.95.59) and the Philadelphia Museum of Art. A trimmed impression in which the number seems to have been erased is in the Ehemals Staatliche Museen, Berlin-Dahlem (187–1913) (grey).

BIBLIOGRAPHY: Woodall No.2.

Executed in aquatint by the sugar-lift process; the angular effects in the foregound (see Pl.**20**) are produced by a broad-nibbed pen. The technique of blocking out the foliage is exactly paralleled in the late wash drawing in the Ehemals Staatliche Museen, Berlin (4666) (Hayes 809) (Pl.**92**). See pp.24–7 above for a discussion of the Boydell series.

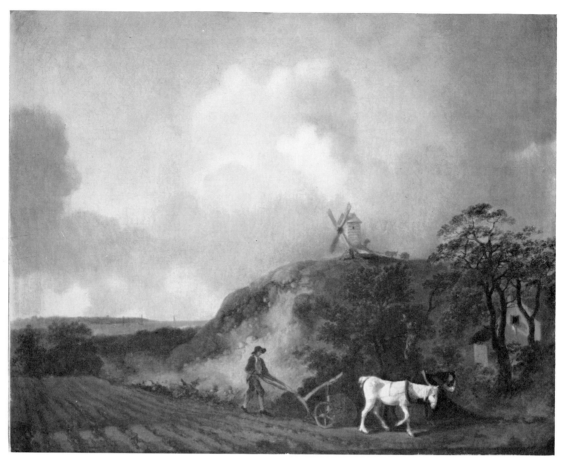

91 Painting. Possibly the subject of No.21.

92 Drawing.

Untraced Print

21 Landscape with Man Ploughing and Windmill (The Suffolk Plough)

Early 1750's

Etching. 16 × 14; 406 × 356.

Only known from the description in Edwards's *Anecdotes of Painters*, 1808 (p.142) which states that the etching 'represents a man ploughing on the side of a rising ground, upon which there is a windmill. The sea terminates the distance. This he (Gainsborough) called the Suffolk Plough. It is extremely scarce, for he spoiled the plate by impatiently attempting to apply the aqua fortis, before his friend, Mr. Grignion, could assist him, as was agreed. Size of the plate 16 in. by 14'.
The subject could be identified with that used by Gainsborough for his painting now in the possession of Colonel S. L. Bibby, Epsom (Waterhouse No.866) (Pl.**91**), which dates stylistically from the early 1750's; the number of copies of this composition has always suggested that it must have been etched or engraved.

BIBLIOGRAPHY: Edwards, op. cit.; Woodall, p.94.

93 Drawing. The subject of No.22.

Untraced Print

22 Wooded Landscape with Horses, Cows and Sleeping Herdsman (Repose)
Mid to later 1770's

Etching (presumably soft-ground). Size about 10 × 14; 254 × 356.

Only known from a note in *The Illustrated London News*, 25 July 1846 (p.55) describing the painting of this subject, then recently acquired by the dealer Hogarth and now in the William Rockhill Nelson Gallery, Kansas City (Waterhouse No.908) (Pl.**95**). This states that 'The shattered tree in the foreground was an afterthought of Gainsborough, as there exists an impression from an etching which the Painter made of this very subject, but in which the tree in question was not introduced, nor the herdsman stretched on the grass.' The tree was indeed an afterthought, and disappeared during restoration *c.*1912–20, though the herdsman remains (Pl.**94**). In the preparatory black and white chalk drawing, also in the Nelson Gallery (Hayes 402) (Pl.**93**), the tree is not featured, and a pentimento close to the sleeping herdsman shows that he was originally posed in a standing position: it is possible (*vide* the description quoted above) that the etching followed this first conception of the design. The etching must date from the mid to later 1770's (the approximate date of both drawing and painting), and probably antedates the closely related subject (No.8) in which the herdsman asleep is in exactly the same pose as in the drawing (after alteration) and the painting.

An impression of this print was formerly in the collection of W. Constable, Arundel (George Williams Fulcher, *Life of Thomas Gainsborough, R.A.*, 2nd ed., London, 1856, p.28 Note), but was not among those purchased from the Constable family by Henry J. Pfungst and now in the Berlin Kupferstichkabinett.

BIBLIOGRAPHY: *The Illustrated London News*, op. cit.; Fulcher, op. cit.

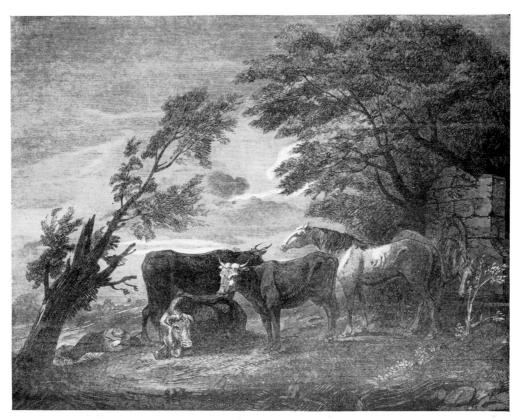

94 Engraving after Gainsborough published 1846.

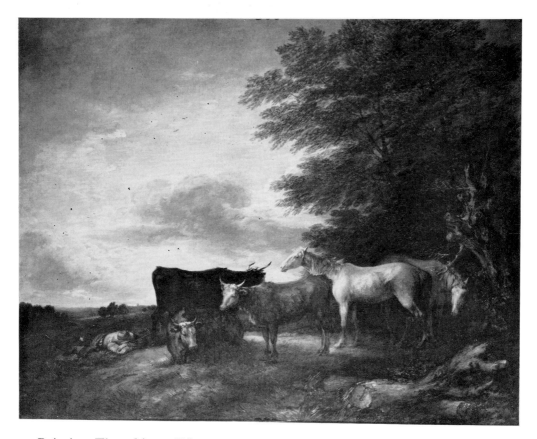

95 Painting. The subject of No. 22.

Concordance

Woodall Nos.	Boydell Nos.	Present Catalogue
1	1	11
2	11	20
3	2	10
4	10	19
5	6	7
6	12	14
7	—	Rowlandson
8	4	5
9	—	4
10	—	13
11	9	6
12	7	18
13	3	9
14	5	12
15	8	16
16	—	8

Index